CW00809323

A FAMILY NAMED SPOT

A FAMILY NAMED SPOT

Photographs by BURK UZZLE

Preface by CHARLIE ROSE

With a short story, "My Heart is a Snake Farm," by ALLAN GURGANUS

fiveTIES

PREFACE

BURK UZZLE MAY HAVE BEEN MY FIRST HERO. In 1962, at the age of 23, he became the youngest contract photographer at *Life* magazine. At that time, *Life* was it—like being on network television. And *it* was about photographs, Burk was a photographer, and he was my first cousin. His accomplishment brought me enormous pride. So I speak from bias, but I've met enough great photographers now to know that they believe—and I believe—that he walks among them. There is a pride of blood in this, and also a pride in seeing in his work things that remind me of the place I came from, viewed through his extraordinary eye.

It took a few years for me to learn just how much I love where I grew up. Irony and eccentricity and quirkiness, the fascinating dialogue between tenderness and toughness, and love of the land and the dignity it ultimately gives a person are all aspects of North Carolina that seem to have touched us both. I was born in Henderson. Burk's hometown was Dunn. His mother was my father's sister. We didn't always see that much of each other, except on family occasions. Early on, though, I knew that I wanted to see the world. And I got lucky. I've been able to do that. But Burk, four years my senior, had already done it. At 17, he went to work for the *News and Observer* in Raleigh. Then came *Life*. And in 1967, he became a member of Magnum. It was all enormously impressive.

There wasn't a lot of art in my home growing up, so it's a question why I have had such a fascination with artists, but it has something to do with what Burk has meant to me over the years. I first came to New York in 1968 with the intention of practicing law. When I was essentially on track to live a rather conventional life, here was a guy—my cousin—creating art of international quality and walking where Henri Cartier-Bresson and Robert Capa walked. His work for *Life* drew upon some of the places where we grew up, and gave me the sense of a rural experience I never had for myself. What Burk always represented to me was a brilliant interpretive eye that understood how to capture what it means to grow up and be shaped by the forces at work in the South.

I remember Burk talking to me about Cartier-Bresson as one of his heroes. Years later I went to Paris and had the great pleasure of meeting Cartier-Bresson. After that first interview, he and his wife, Martine Franck, invited me to have lunch, just the three of us. I asked him about Burk, and I had the opportunity to hear him praise Burk's photography. And that just reinforced what I believed all of those years during which, even when we weren't able to see each other, I had followed his work.

I do many interviews with artists—photographers, painters, filmmakers. I'm not an expert in those fields, but I know something about what makes an artist tick. And Burk sees things that only great photographers, painters, and filmmakers see. I can only think about this in terms of what I do. I can read about somebody and just know how the conversation will go, what will make it sing. Burk can look at a moment in life, and know how it will appear after he takes a photograph. And there's genius in his ability to do that, to look at something as only a true artist can.

It's hard for me not to reflect on how proud I've been to be in the same family. In these photographs—taken in recent years on Burk's many trips across the country—I see the work of a man who has stayed very close to the roots that nourished him. Burk has said it best himself: "Small towns and ordinary places interest me most. They are what I am and where I feel the investment of the unspoken. Driving on small roads reminds me of growing up in the South, where I imagine I see the music of the ghosts. In the moment, in the place where the ordinary reveals itself to be epic, is my favorite time to be alive, to have my camera, and to see."

CHARLIE ROSE
Bellport, August 2005

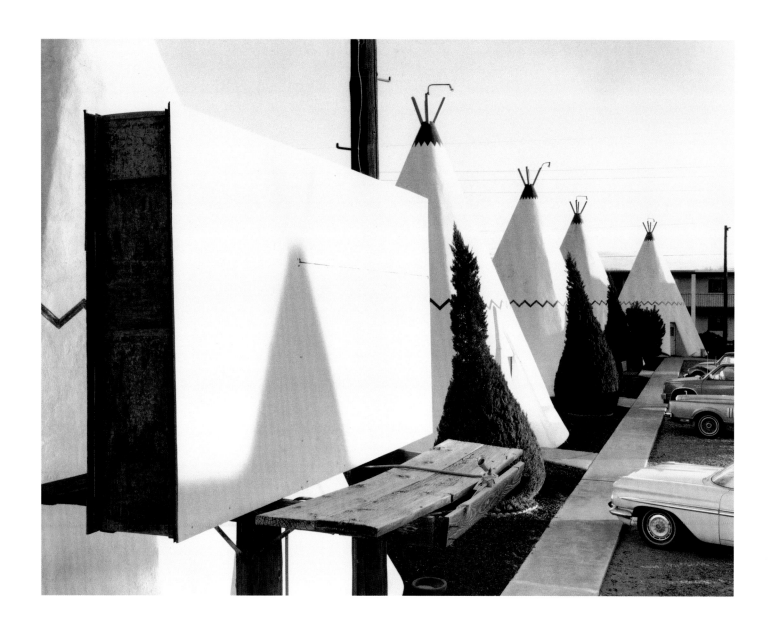

Wigwam Motel, Arizona, 2005

Wow Cows, Vermont, 2003

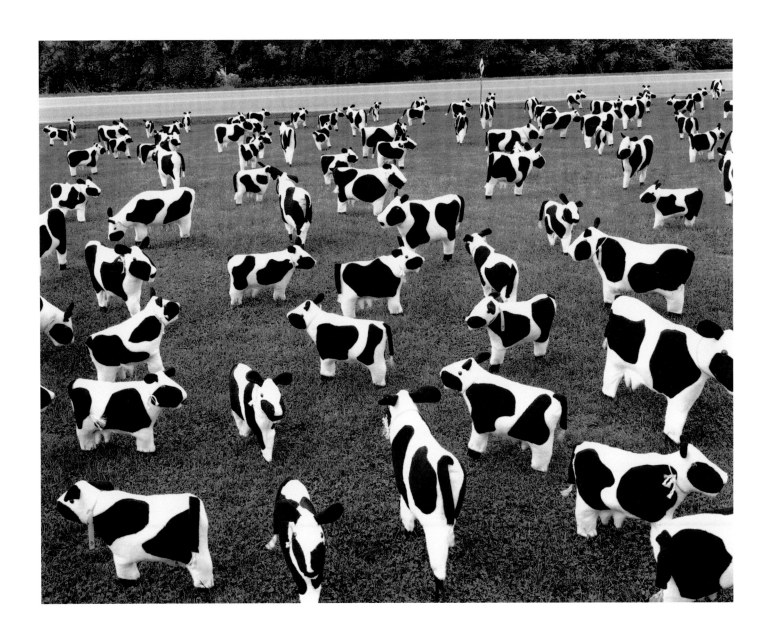

River Bank Dive, Georgia, 2001

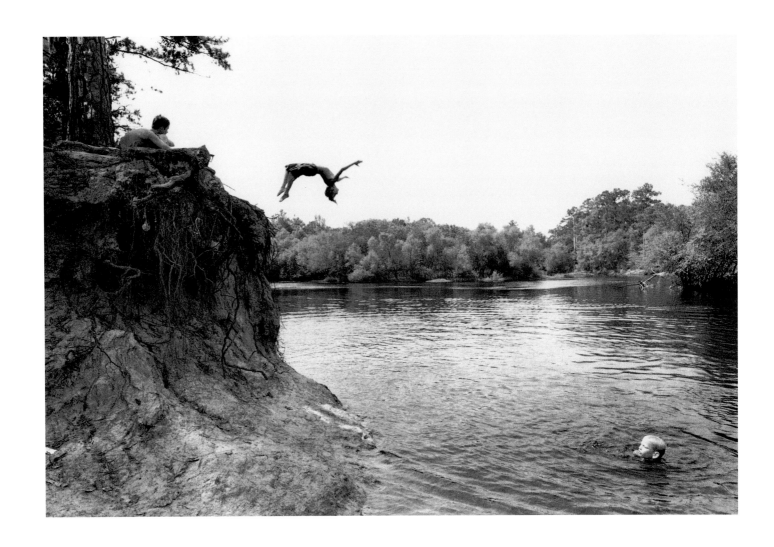

Couple on Bench, Maine, 1996

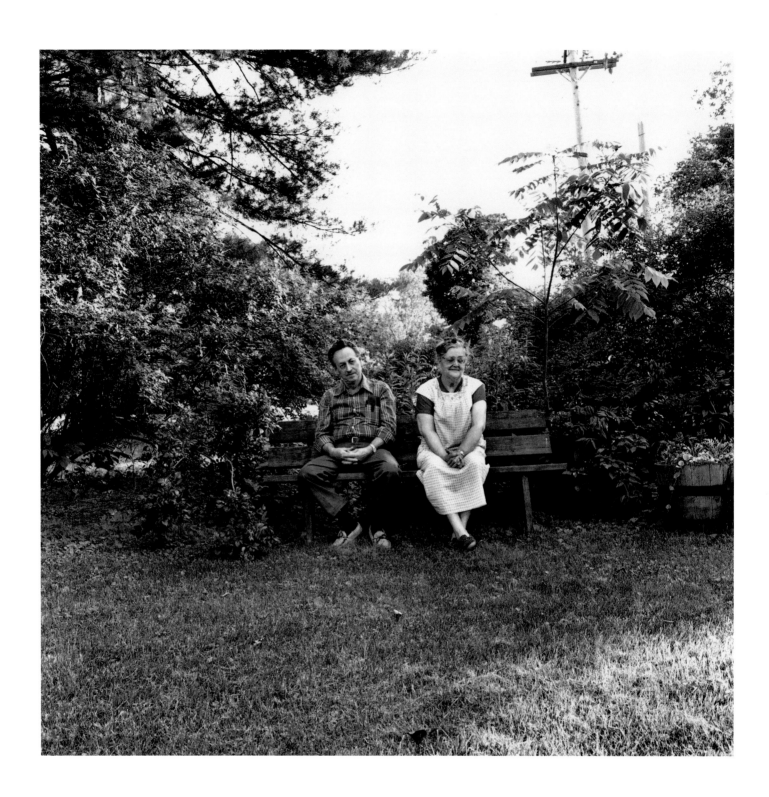

Long White Jeans, Selma, Alabama, 1997

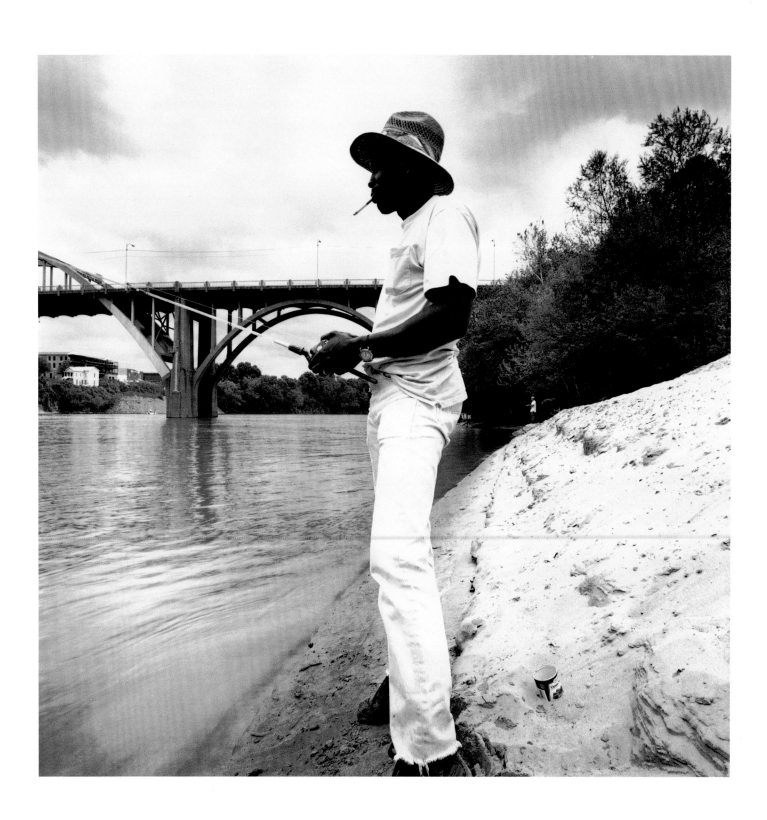

Working Pants, Smithfield, North Carolina, 2002

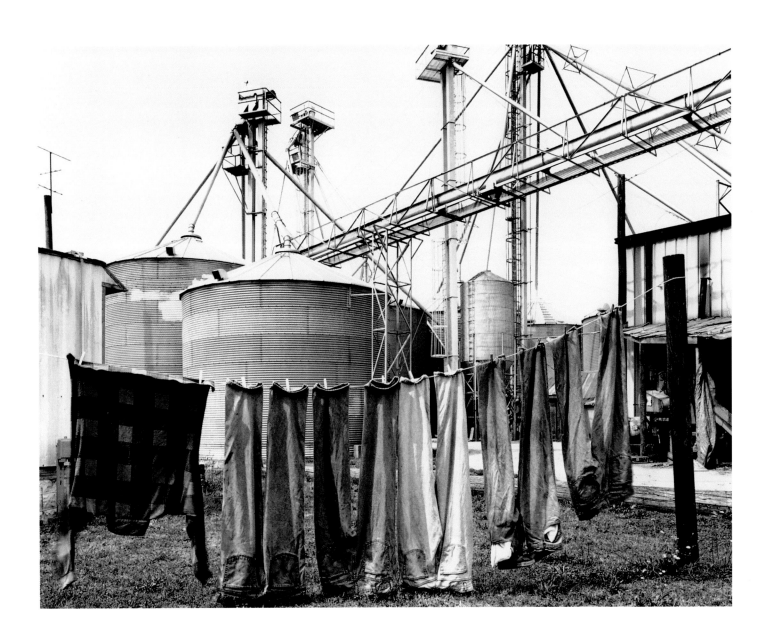

Legs, Vermont, 2002

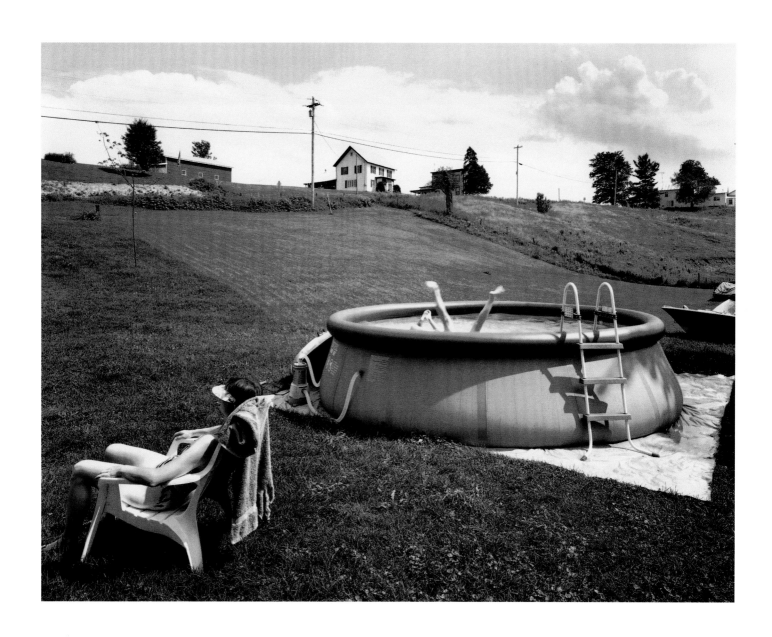

Roadside Food Stand, Mississippi, 1997

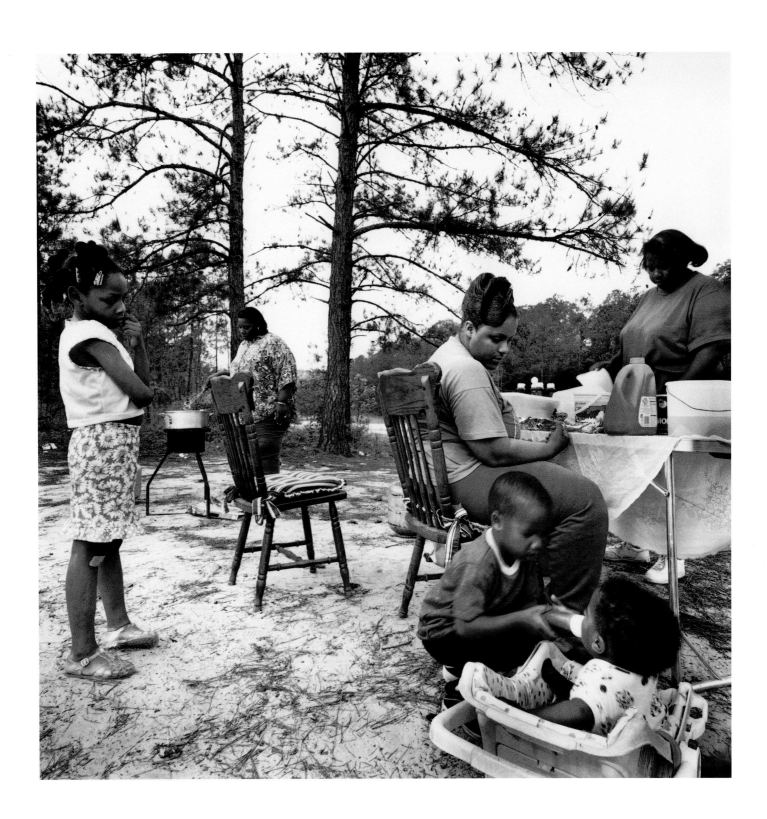

Short Garage and Cow, South Carolina, 1997

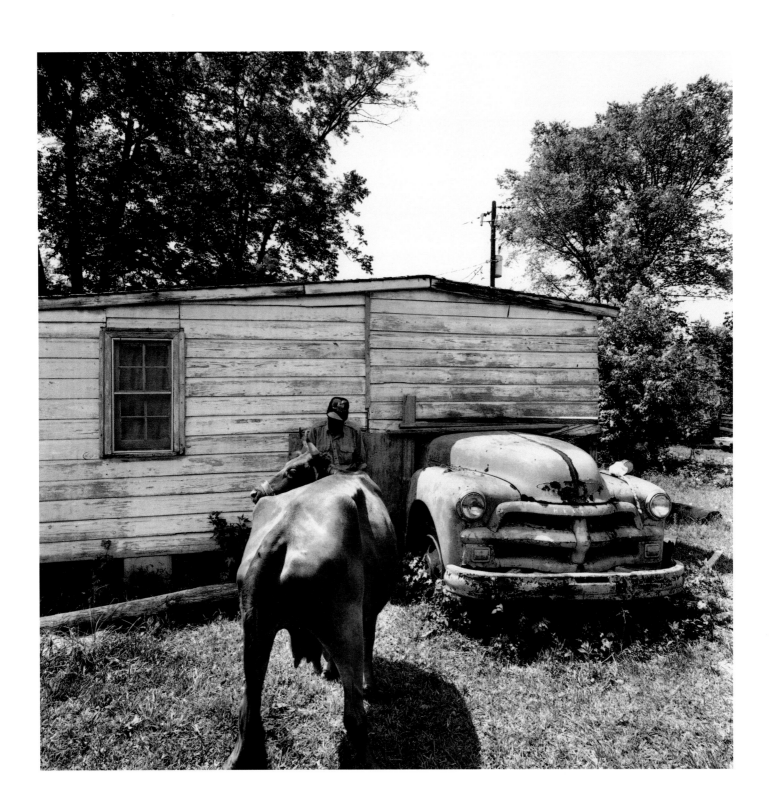

Couple with Dolls, Plant City, Florida, 2002

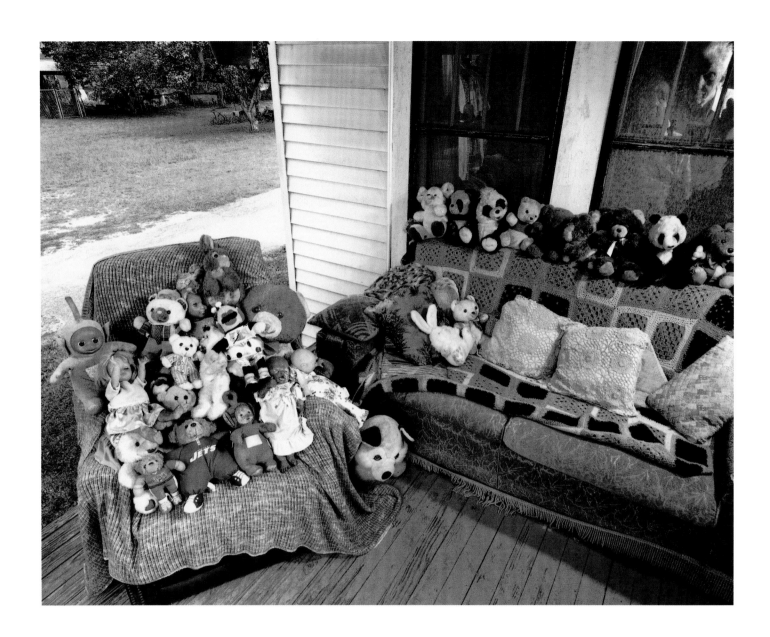

Bull and Zebra at Santee Exit, Santee, South Carolina, 2004

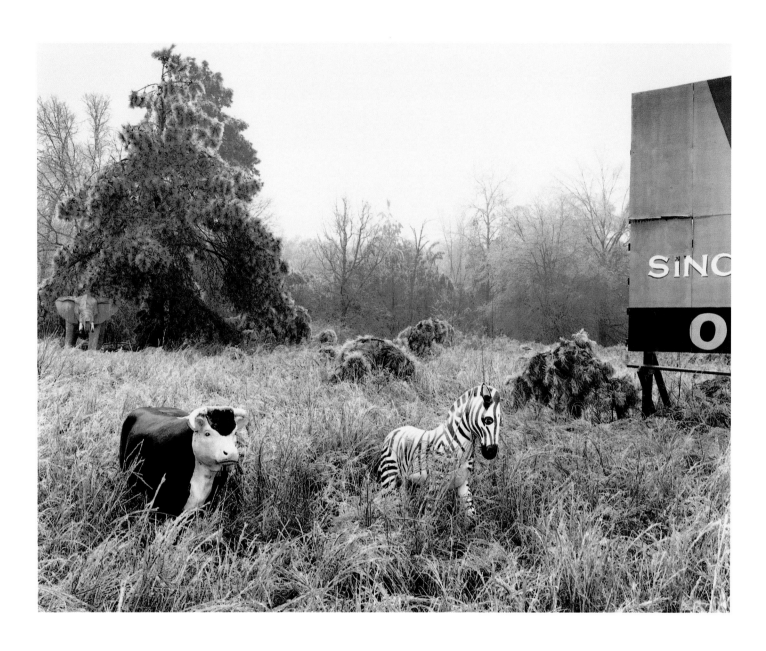

Really Clean Oak Trees, Plant City, Florida, 2002

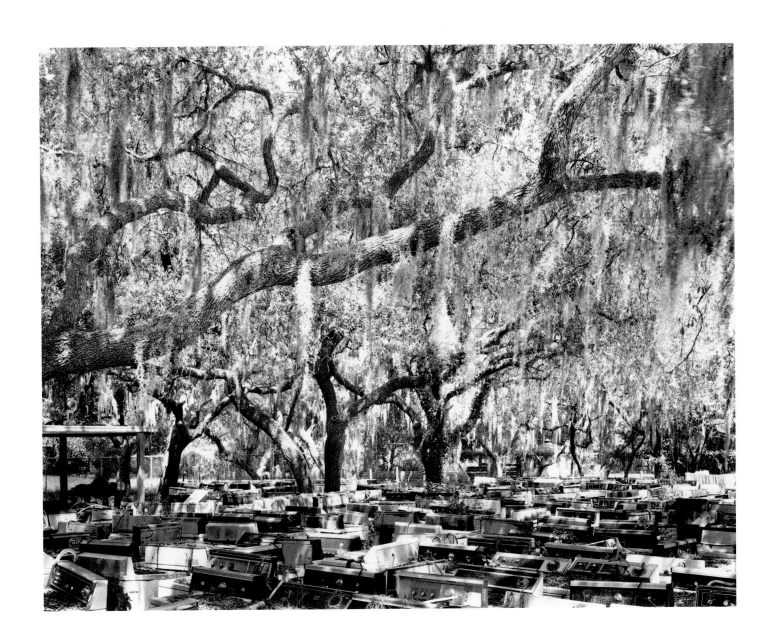

Union Camp, Maine, 1999

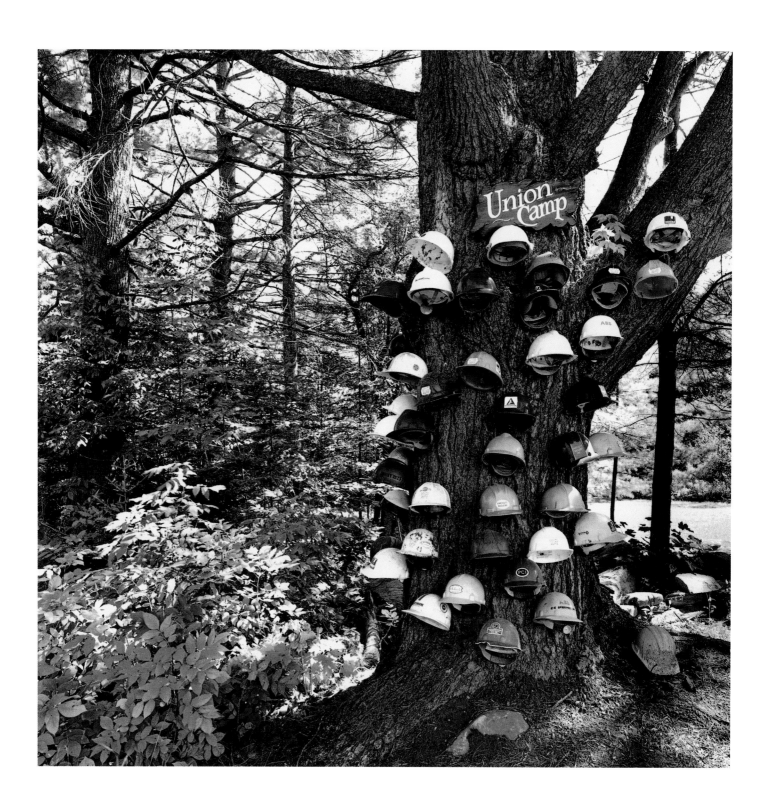

Beef Jerky Lady, Orlando, Florida, 1999

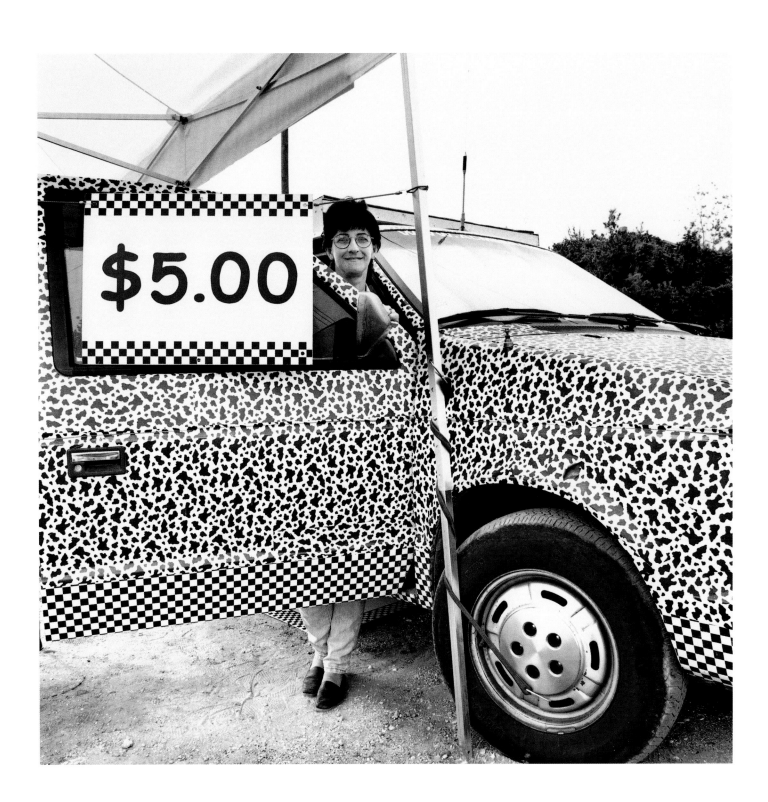

Three Wise Men and One Wise Dog, Georgia, 1999

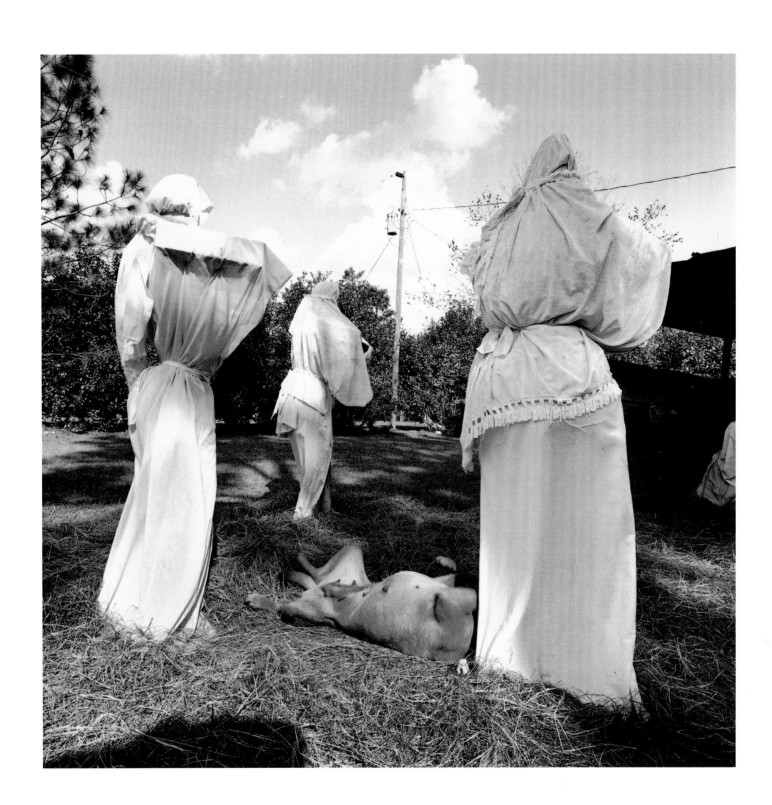

Mobile Home with Grave Markers and Columns, Louisiana, 2002

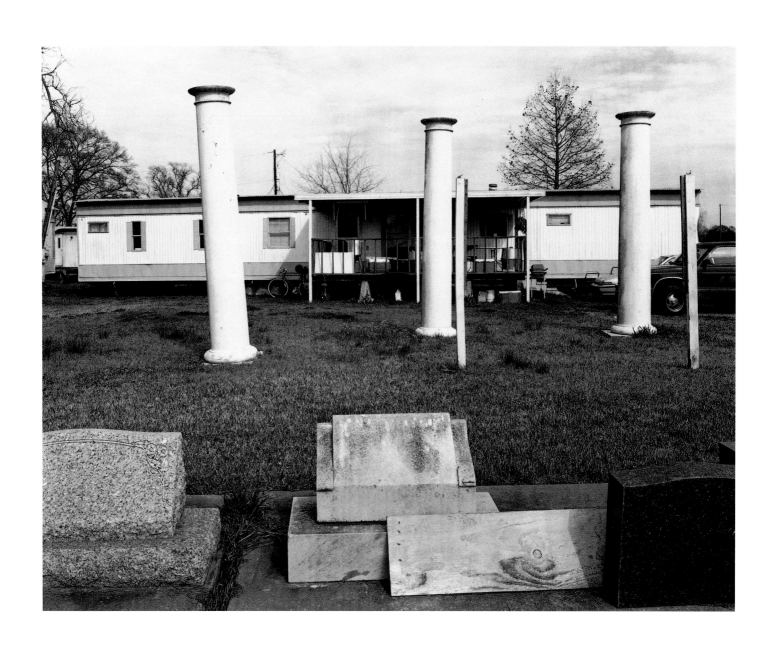

Coppertone Girl, Miami, Florida, 1996

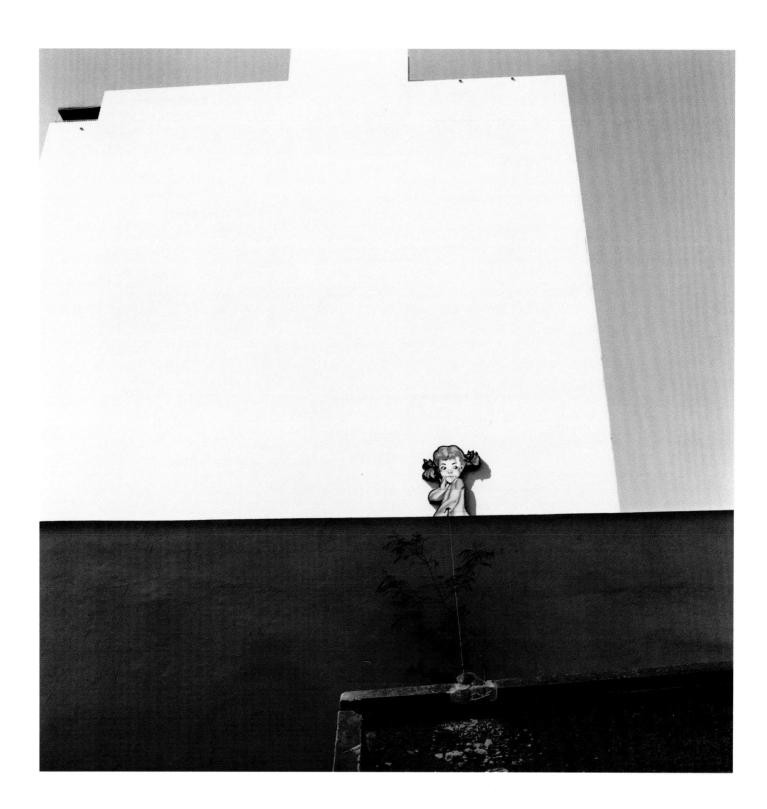

Star Warehouse, South Carolina, 1997

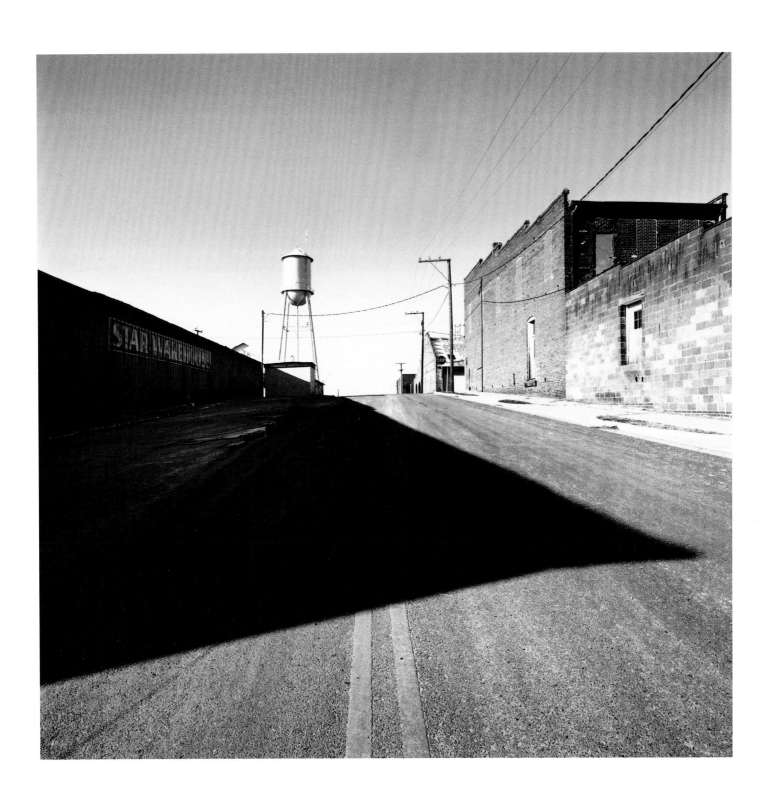

Field of Crosses, Georgia, 2001

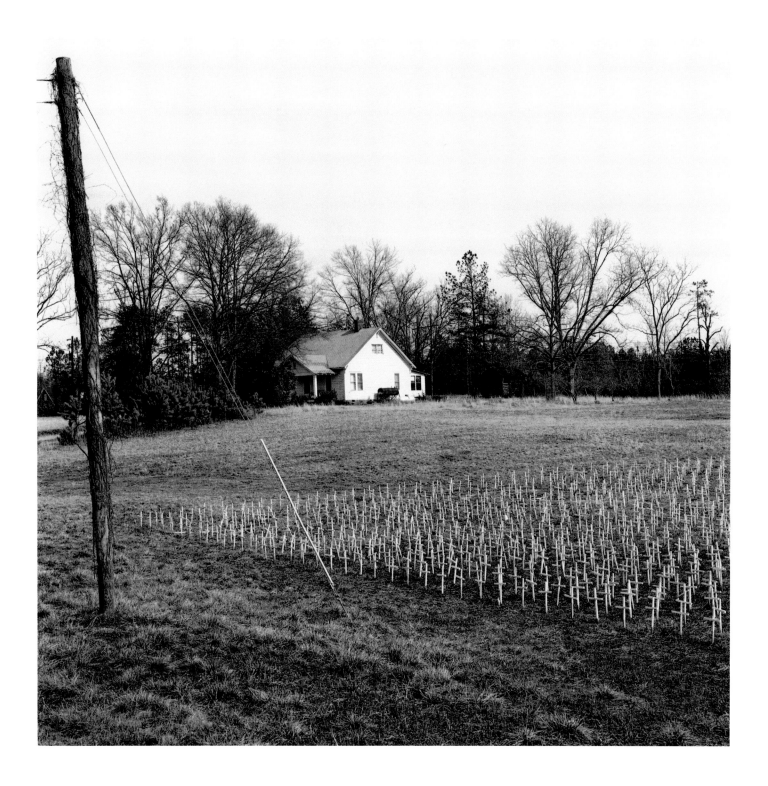

House with Water View, Virginia, 1997

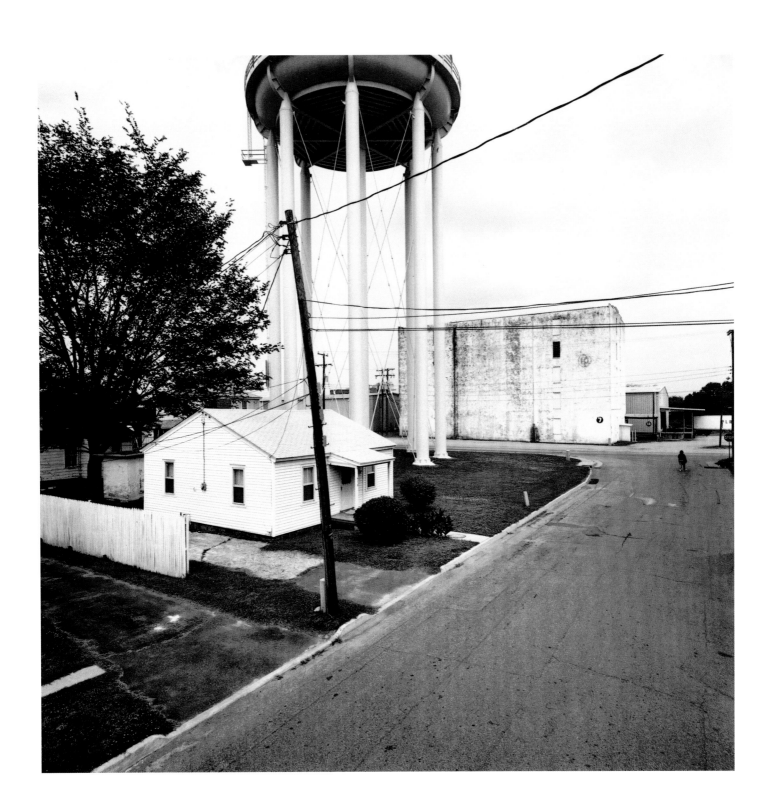

Dancer on Break, Daytona Beach, Florida, 1997

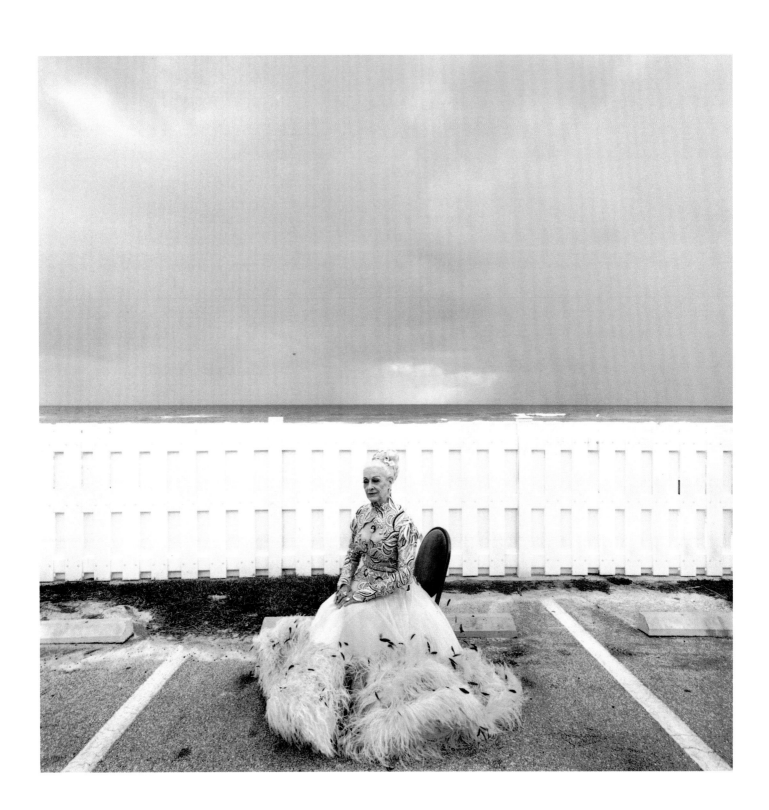

Three Tired Crosses, Mississippi, 2002

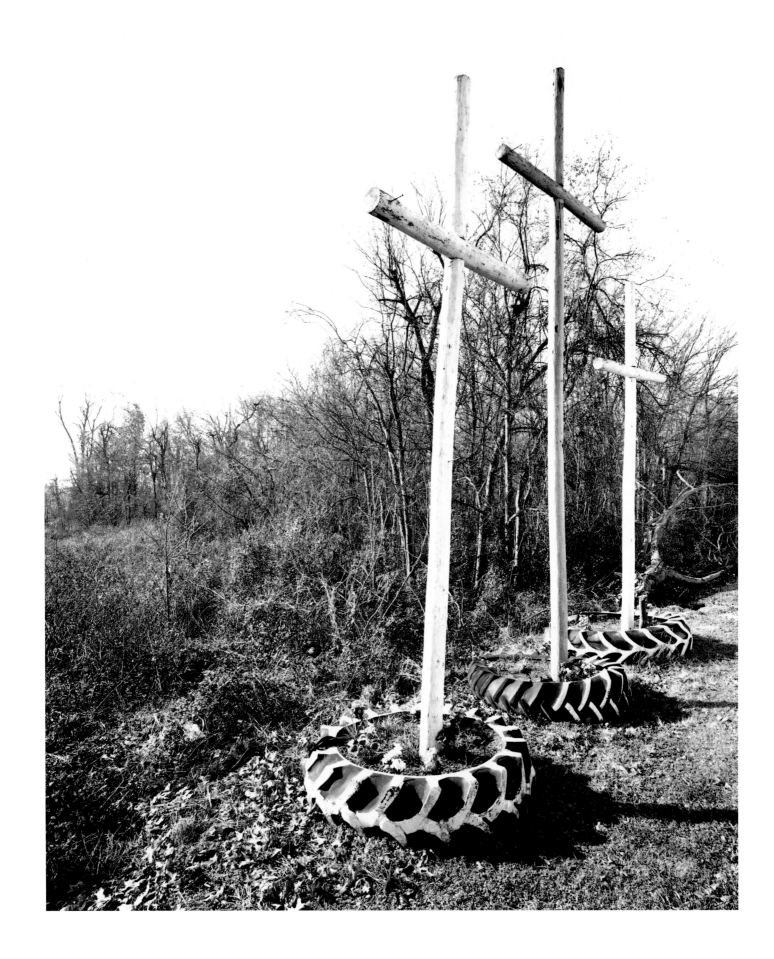

Superman, Illinois, 2002

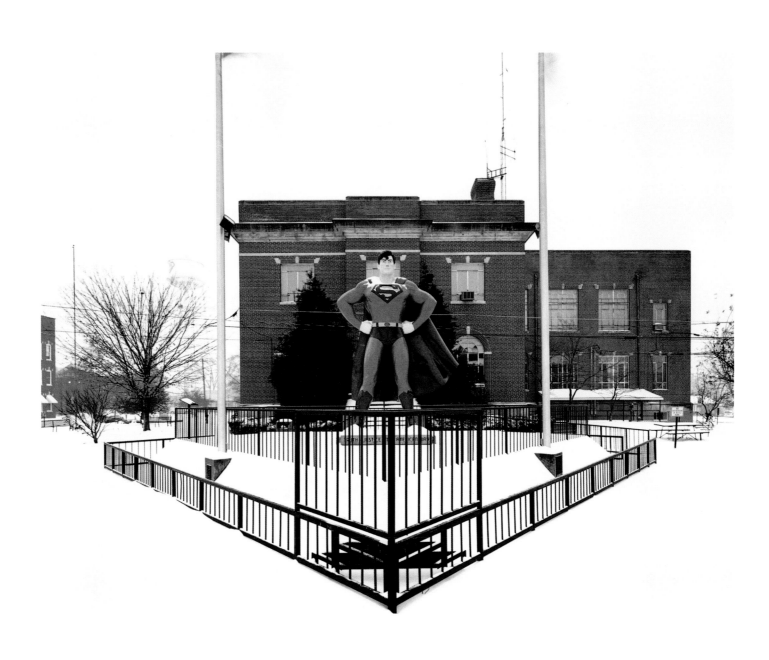

Pole Tree, Delaware, 1999

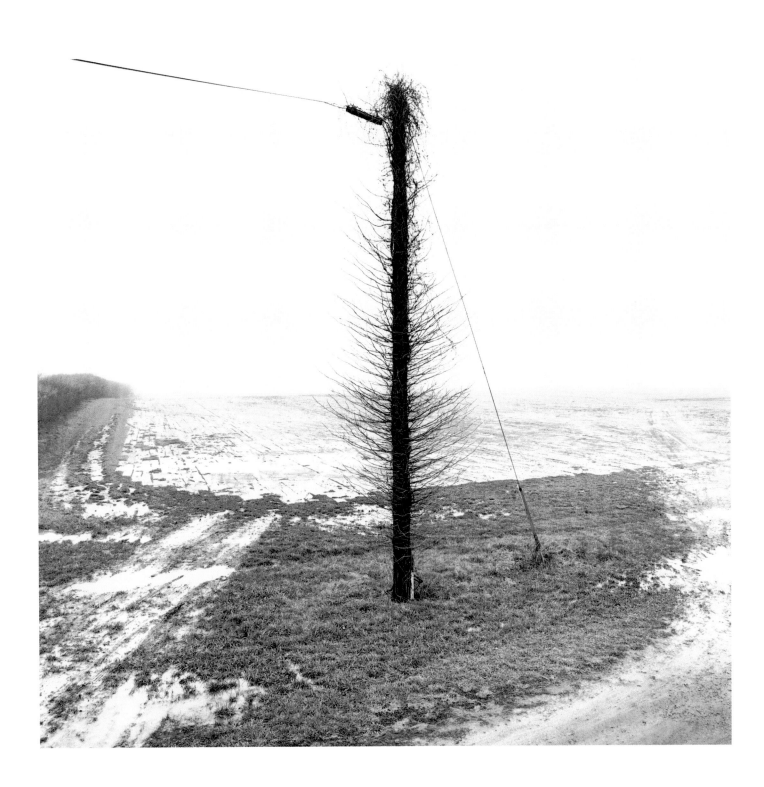

Grave Store with Silos, Oklahoma, 2005

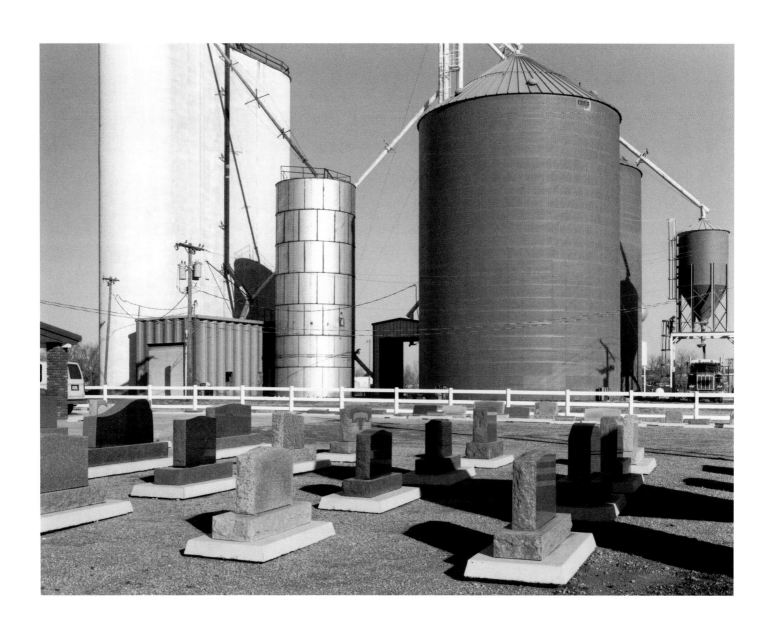

Cadillac, Church, and Hot Dog, Maine, 1996

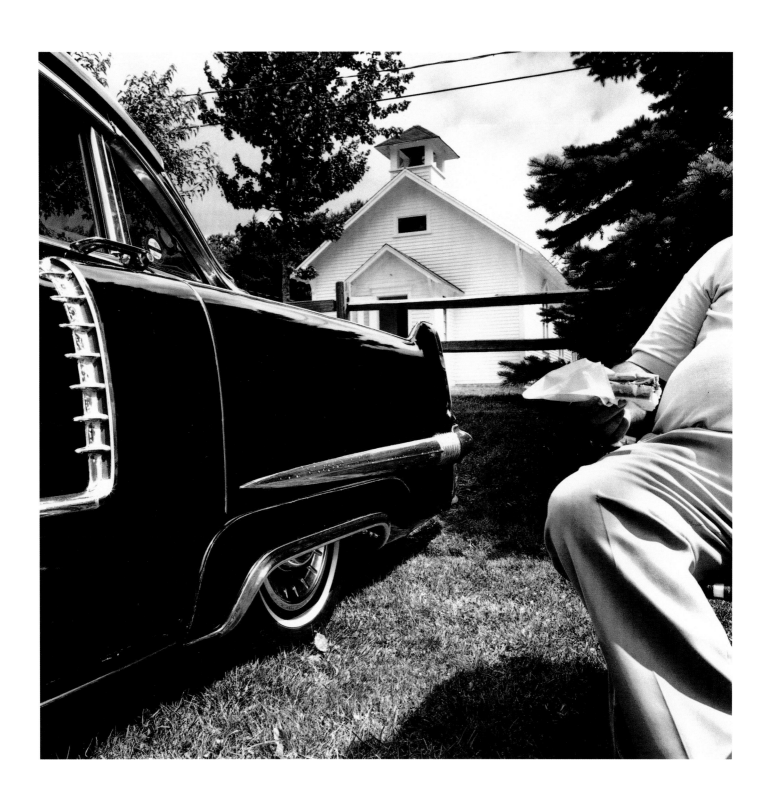

Flag Door with Flag Bike, South Carolina, 1999

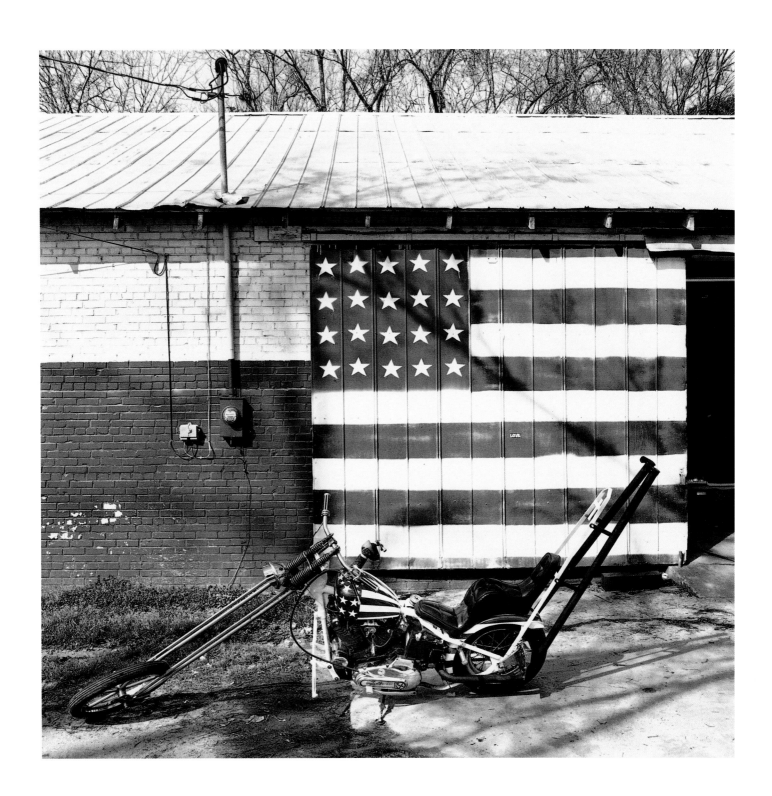

Painted Tire and Thunderstorm, North Carolina, 2001

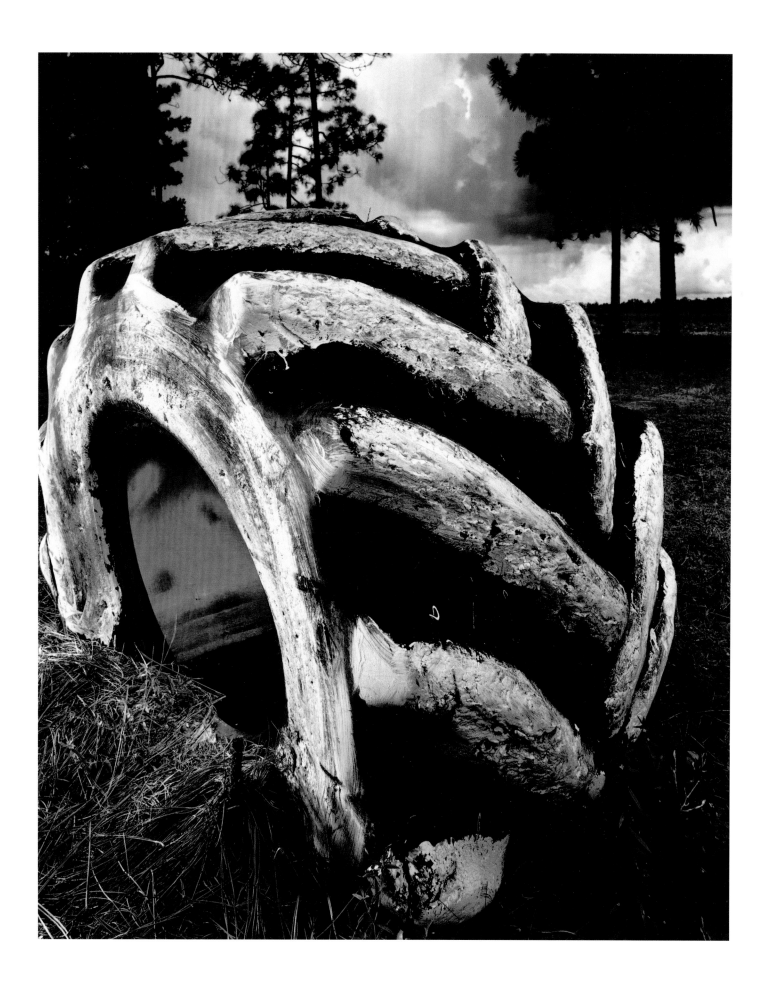

Well-Oiled David, Tampa, Florida, 2000

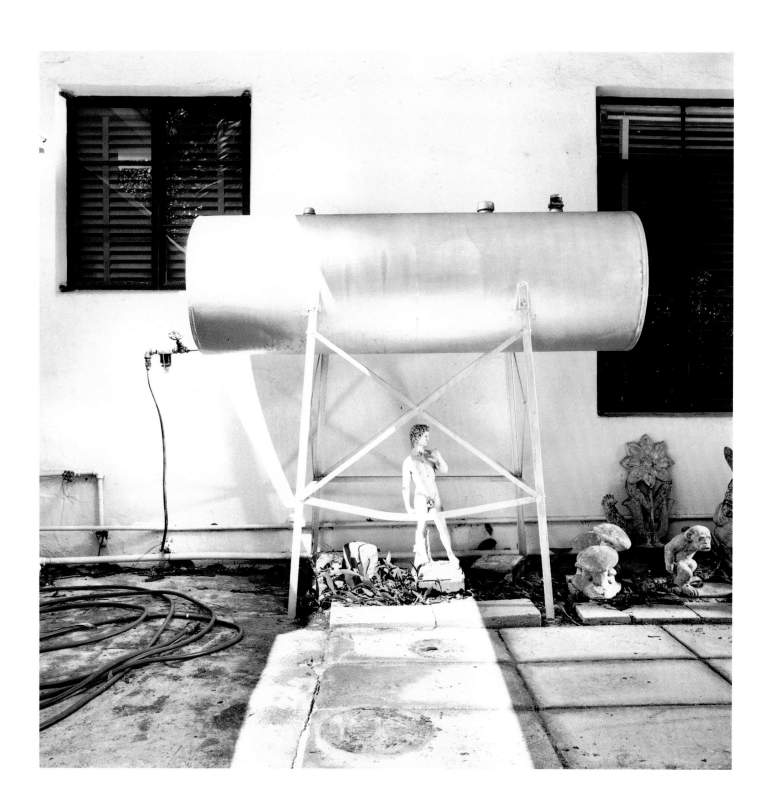

Frisky Cool Lady, Daytona Beach, Florida, 1997

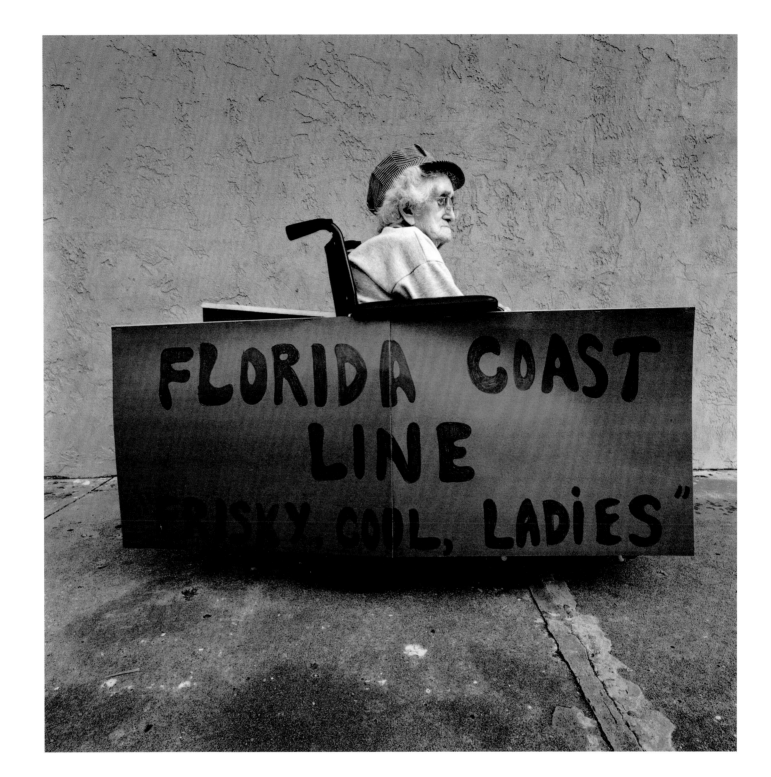

Freightliners, North Carolina, 2005

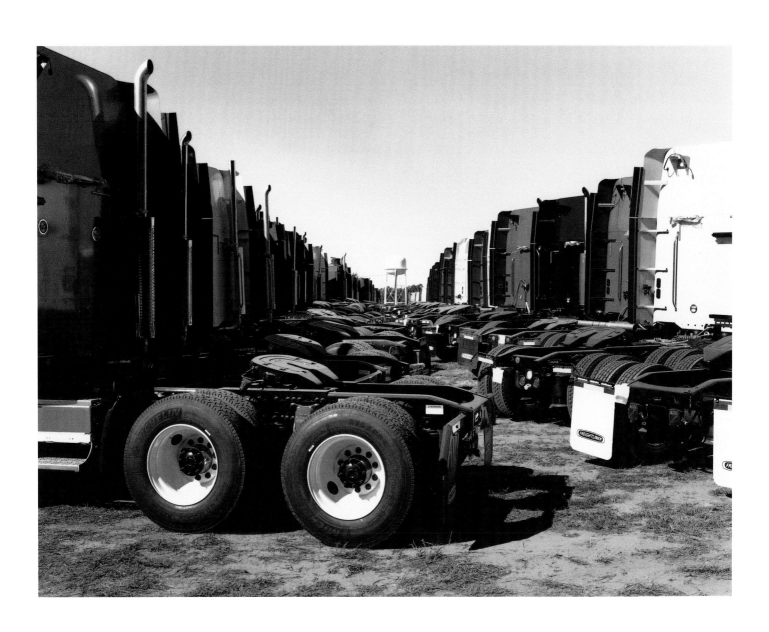

Mustang Girl, St. Petersburg, Florida, 2001

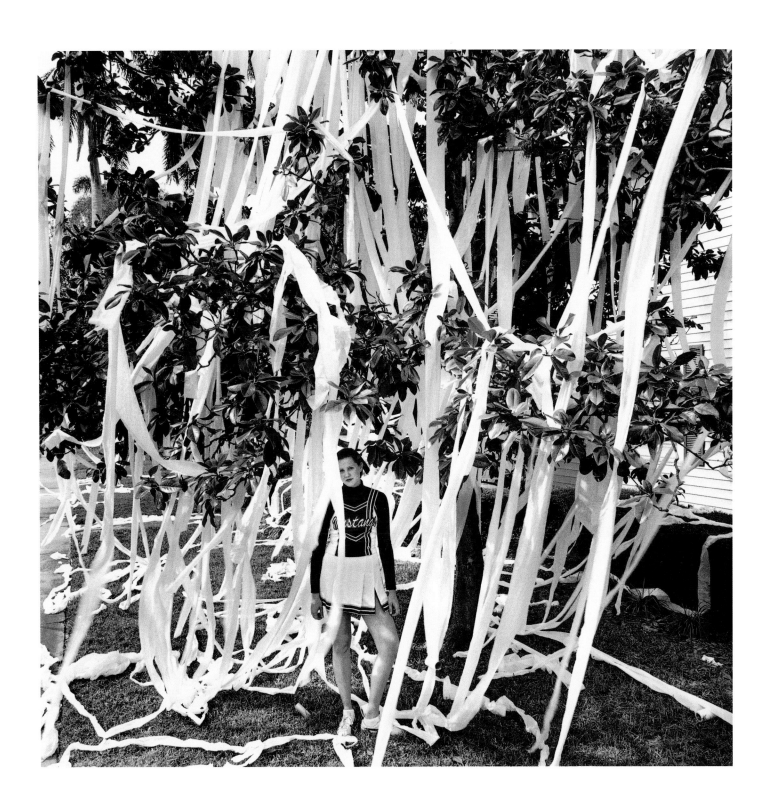

Yard Sale, Florida, 1997

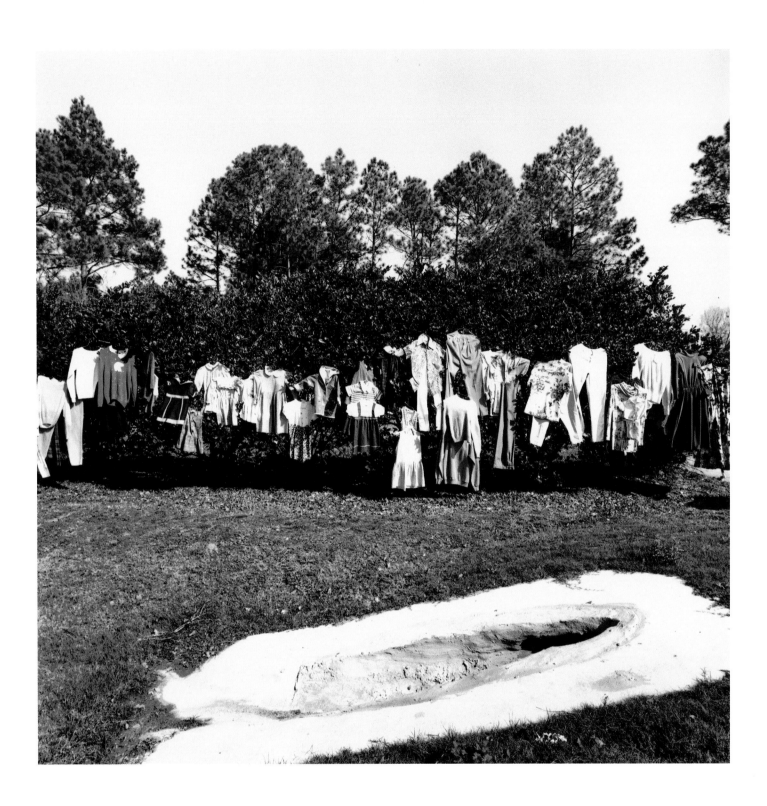

Tree in Big White Tire, North Carolina, 2001

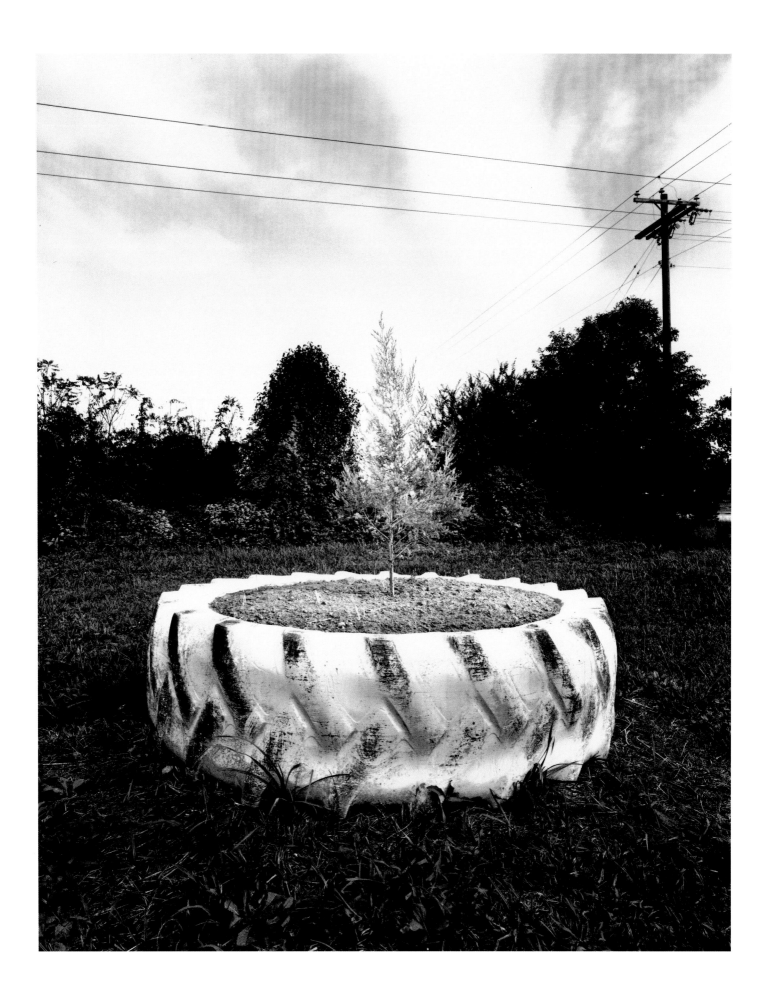

Deer Tree, North Carolina, 2005

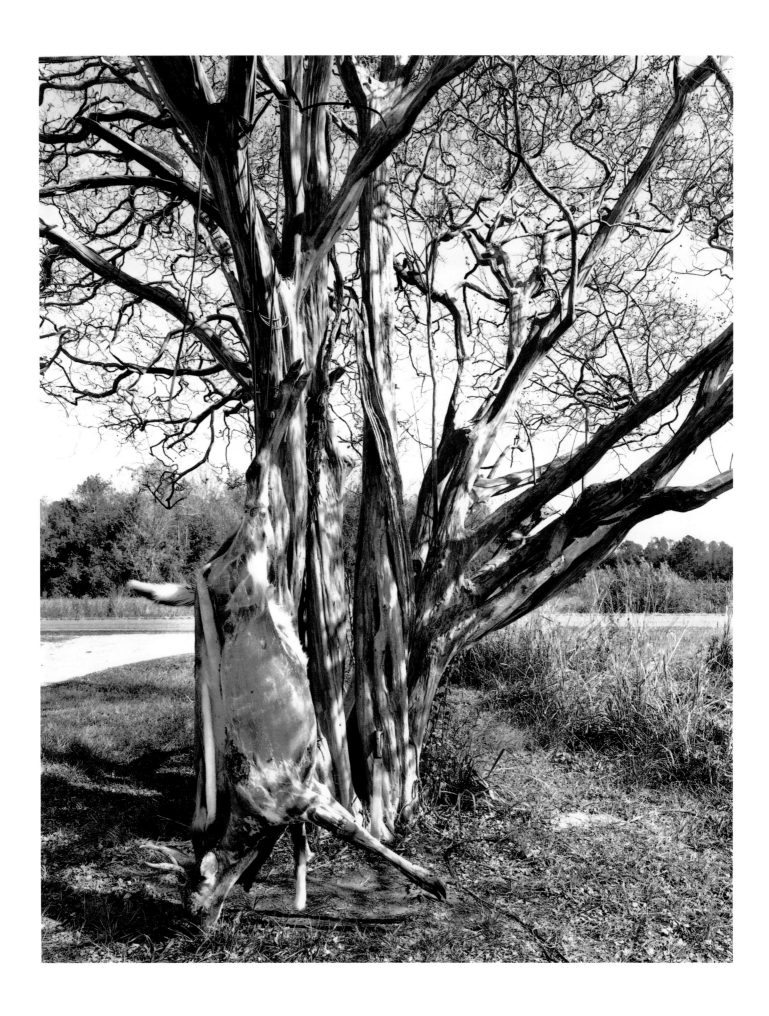

Shoe Tree, Nevada, 2003

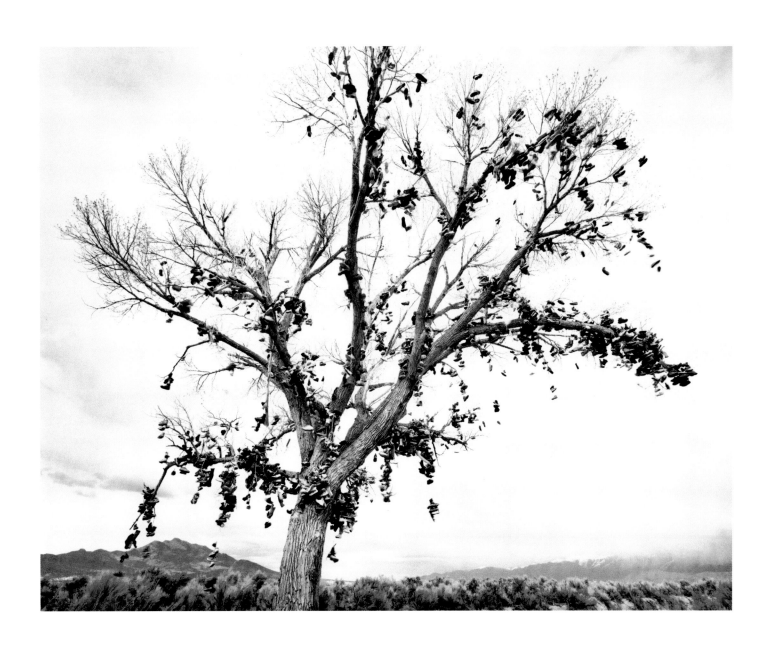

Cans with Flag and Ram, Miami, Florida, 2001

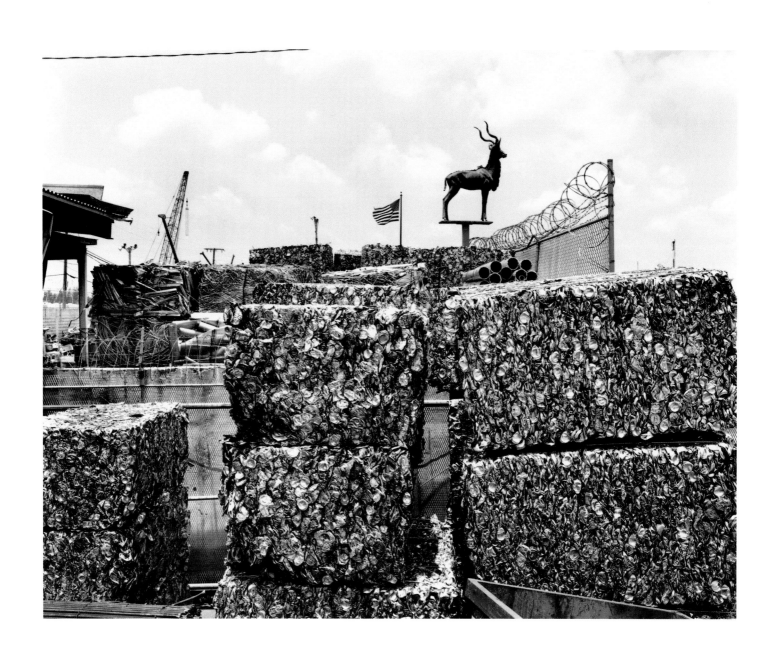

Windstorm, North Carolina, 2000

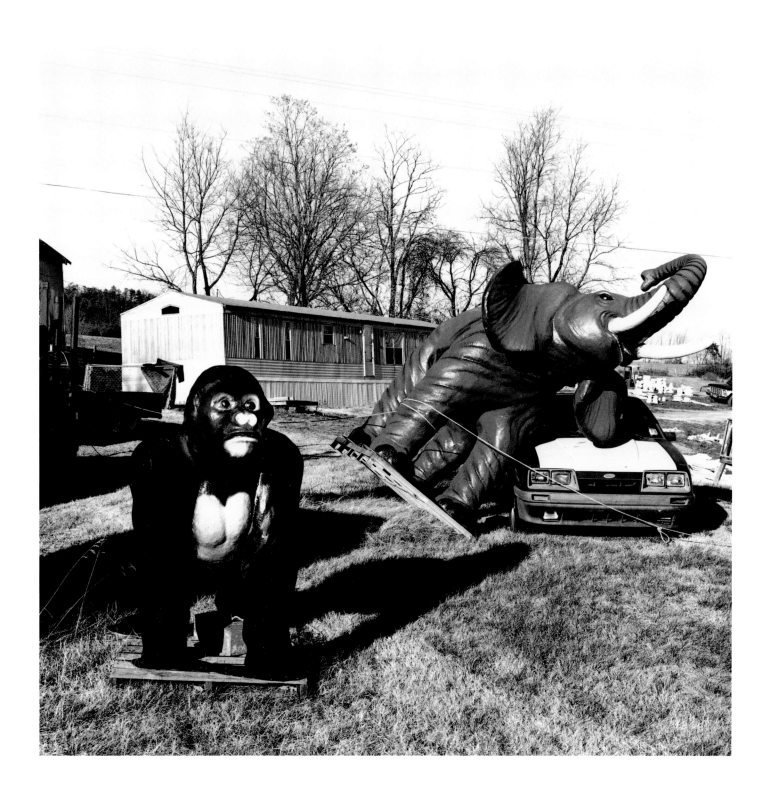

Lady in Flag Suit, Daytona Beach, Florida, 1997

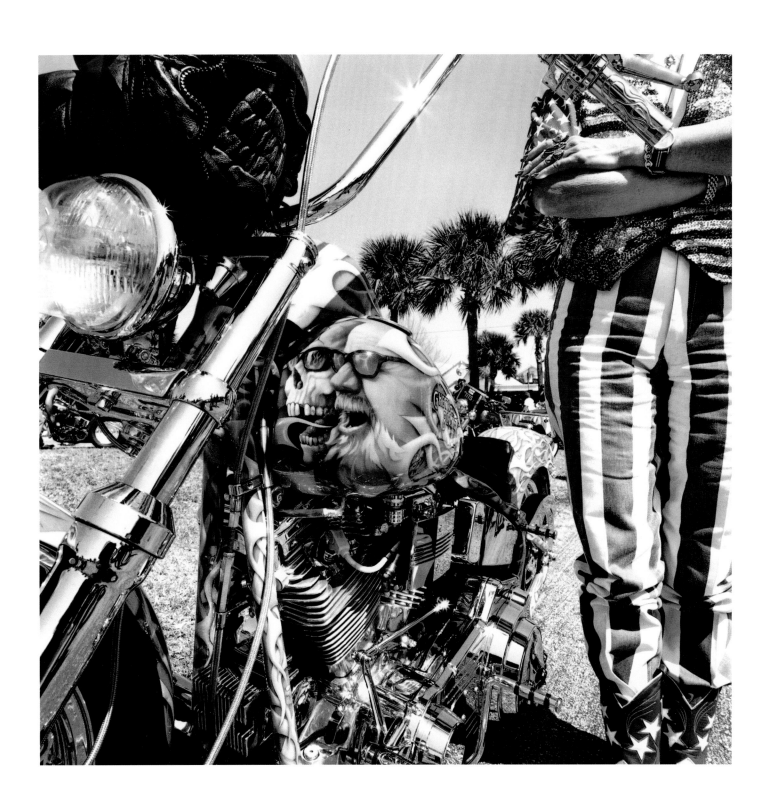

Jesus Saves with White's Tires, Wilson, North Carolina, 2001

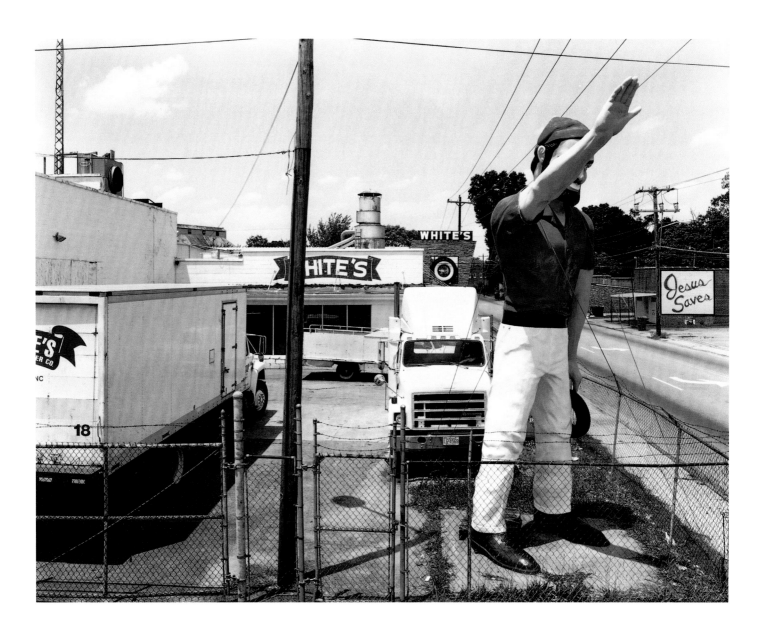

Four Horses and Three Posts, Orlando, Florida, 1996

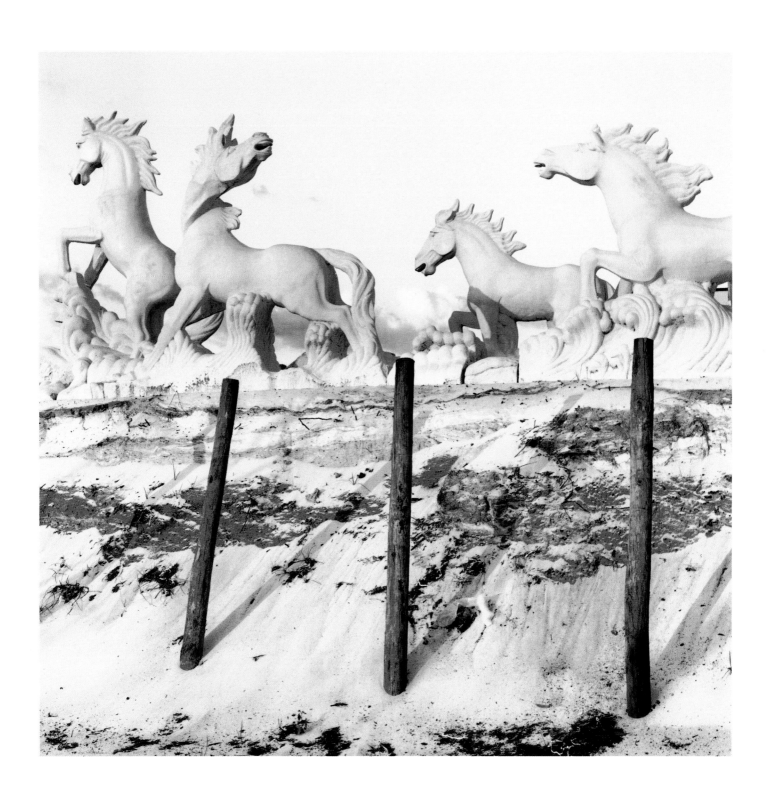

Main Street Skin Caboose, Daytona Beach, Florida, 1995

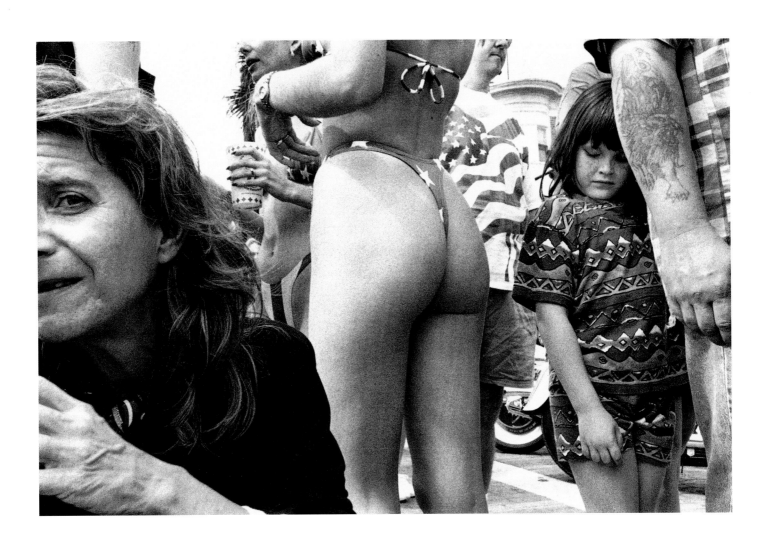

Book of Love, Daytona Beach, Florida, 1997

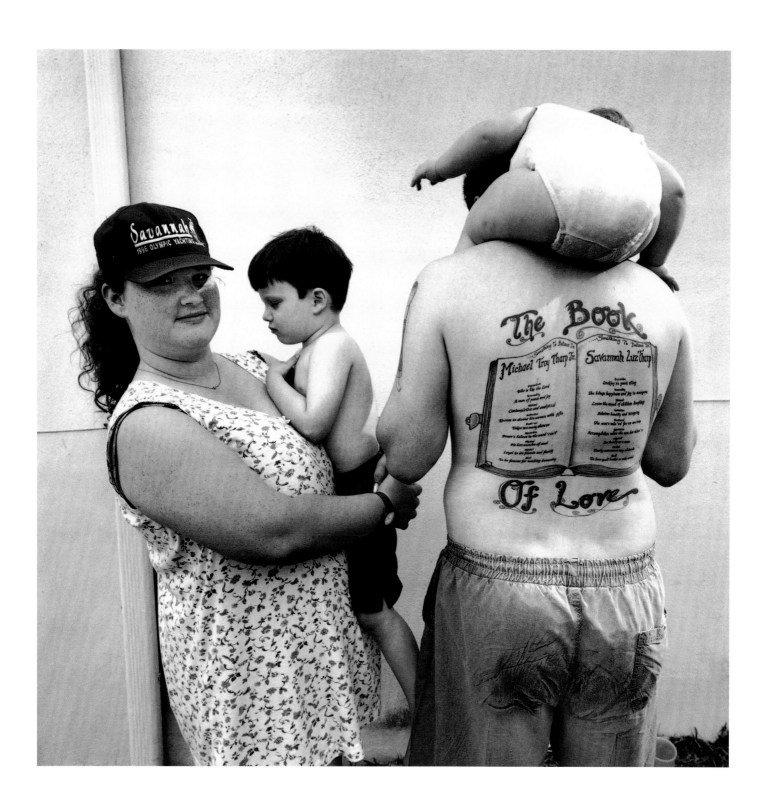

Double Portrait, South Carolina, 2000

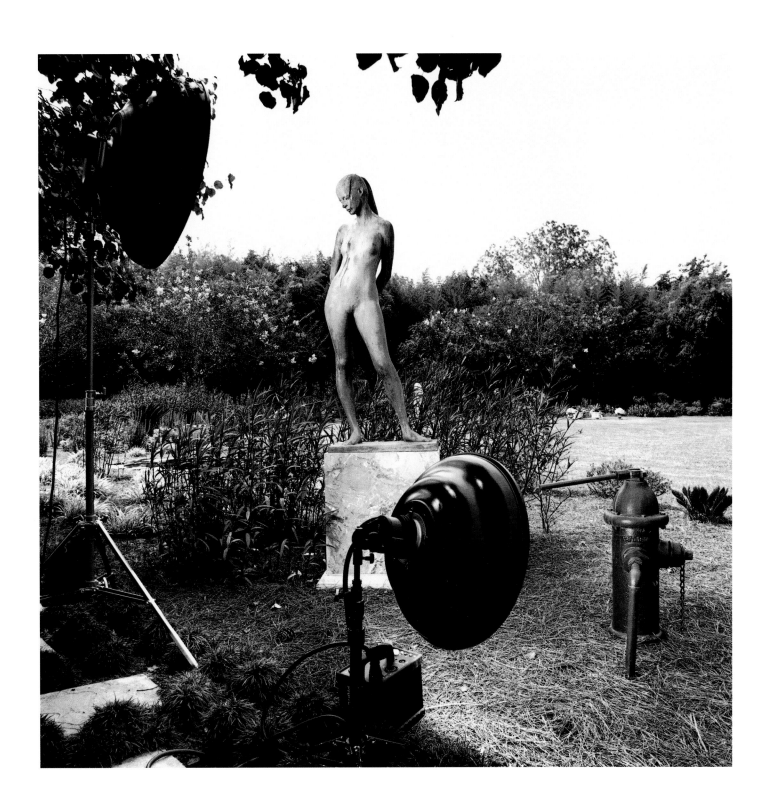

Jesus Loves You, Daytona Beach, Florida, 1997

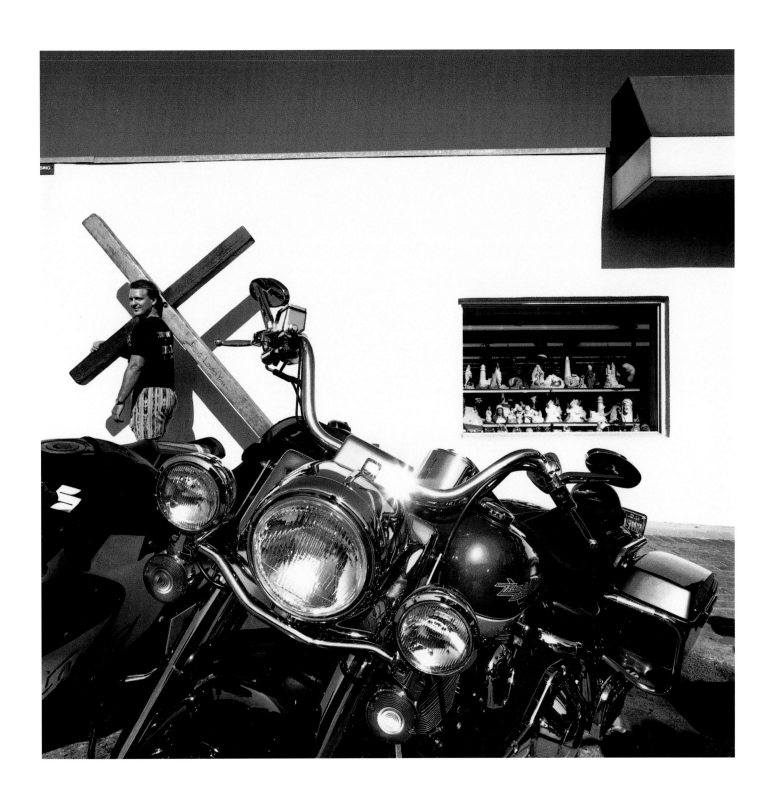

Cape Cod Flag, Cape Cod, Massachusetts, 1998

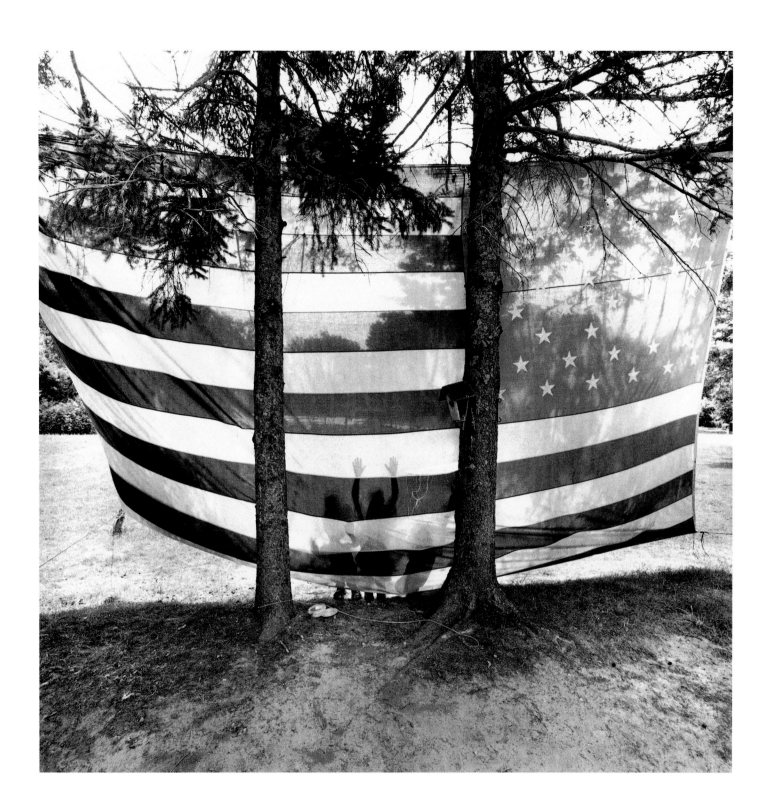

Young Man on Dirt Road, Alabama, 1997

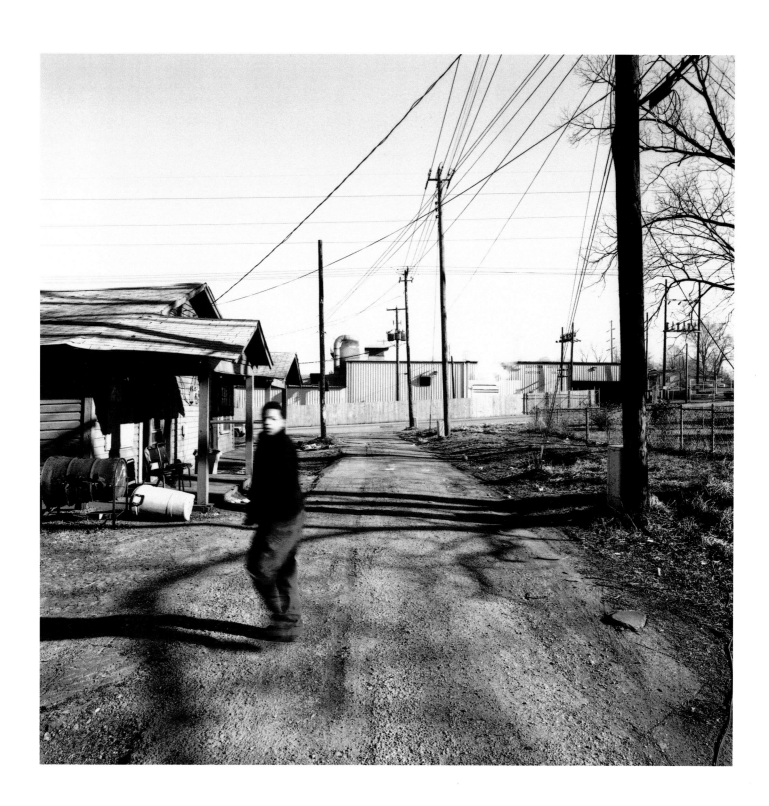

Child of Circumstance, Daytona Beach, Florida, 1998

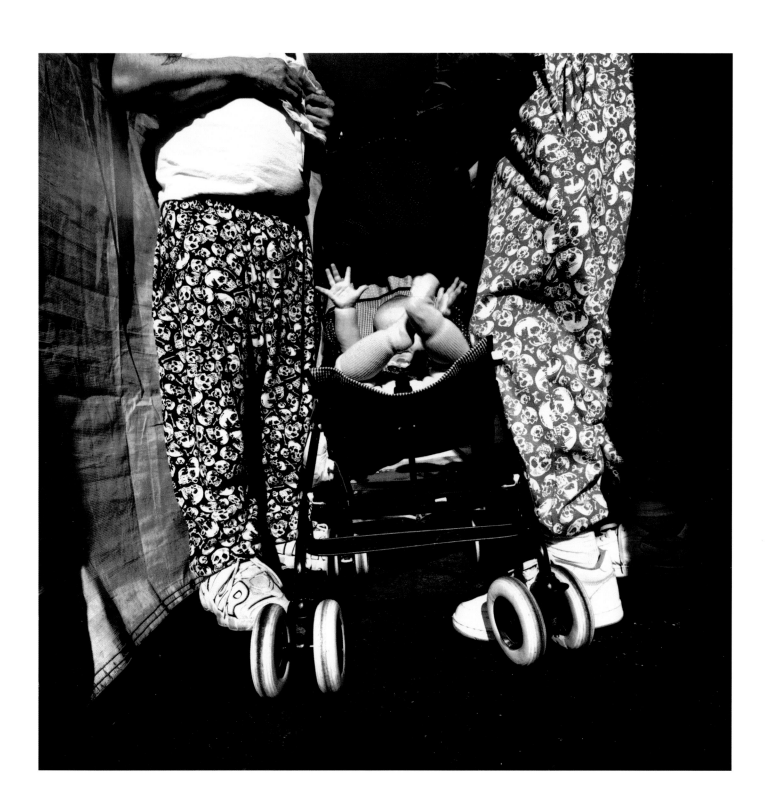

Safe Mail, New Mexico, 2003

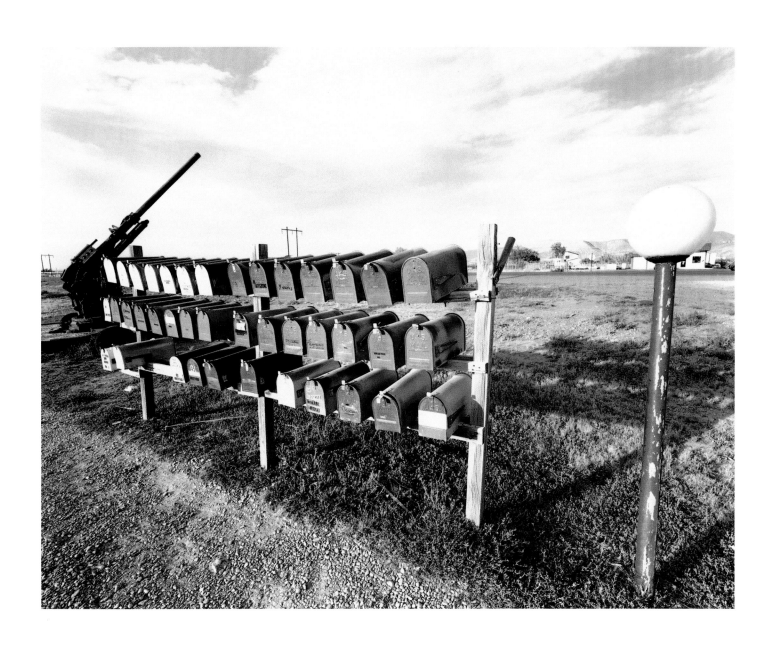

Farm Flag, Vermont, 1997

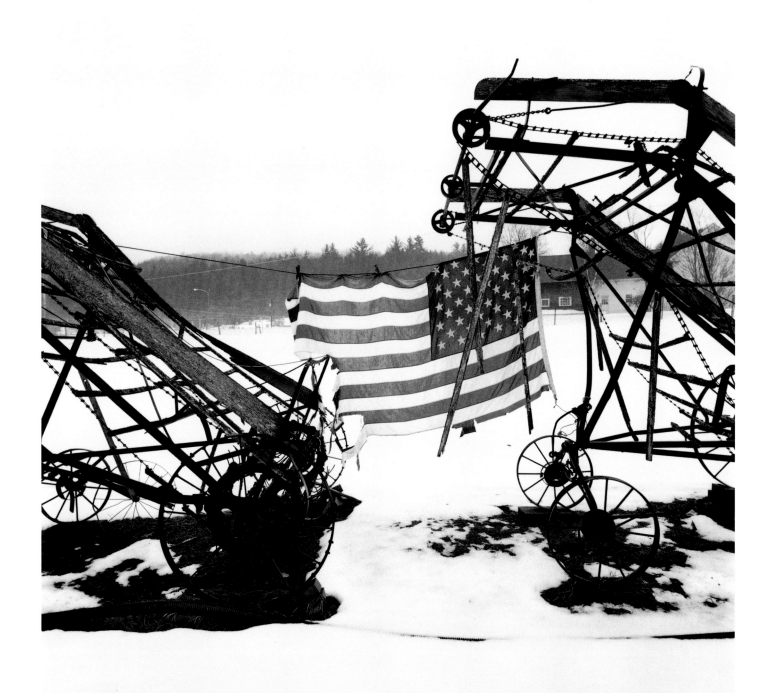

Cactus Store, Yuma, Arizona, 2005

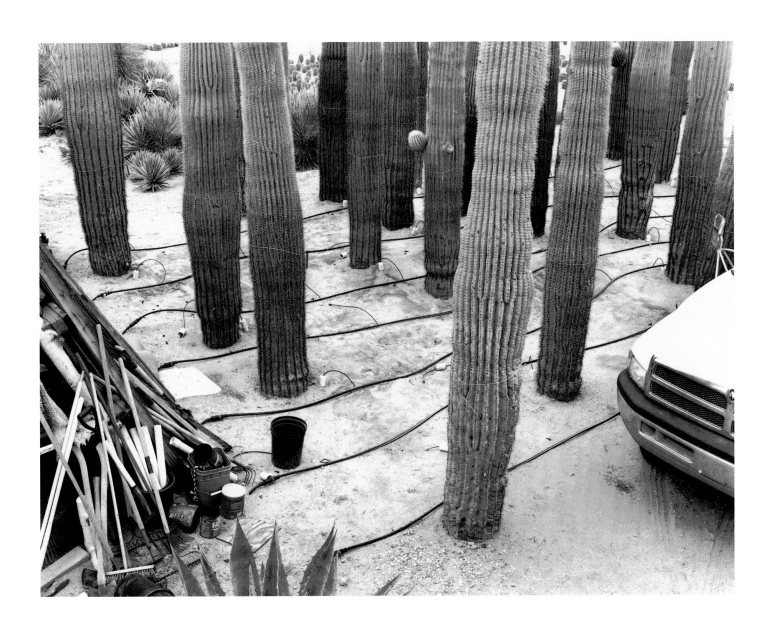

Family and Friends, Daytona Beach, Florida, 1997

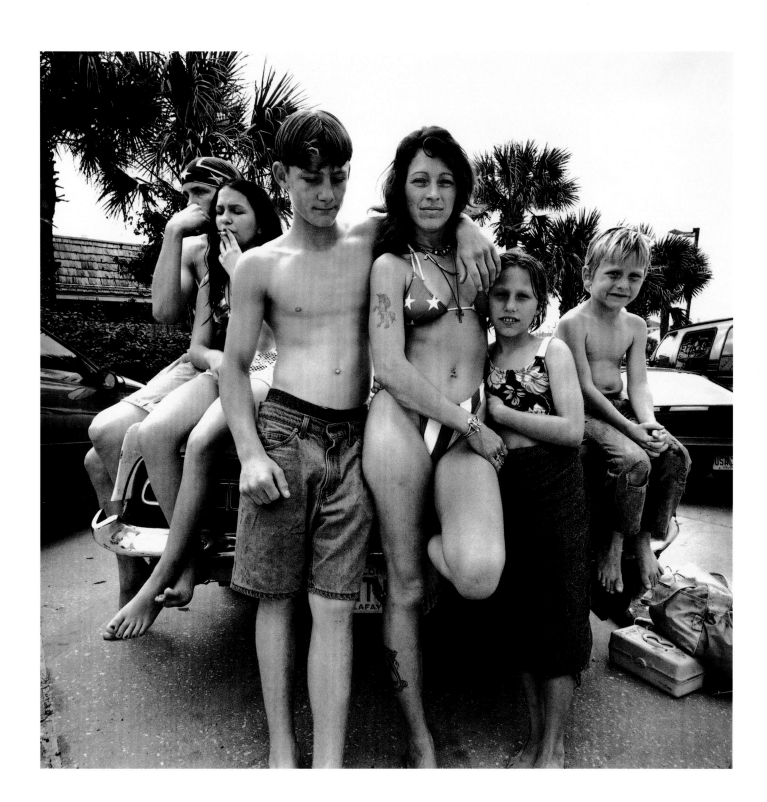

Man in Garage, Daytona Beach, Florida, 1998

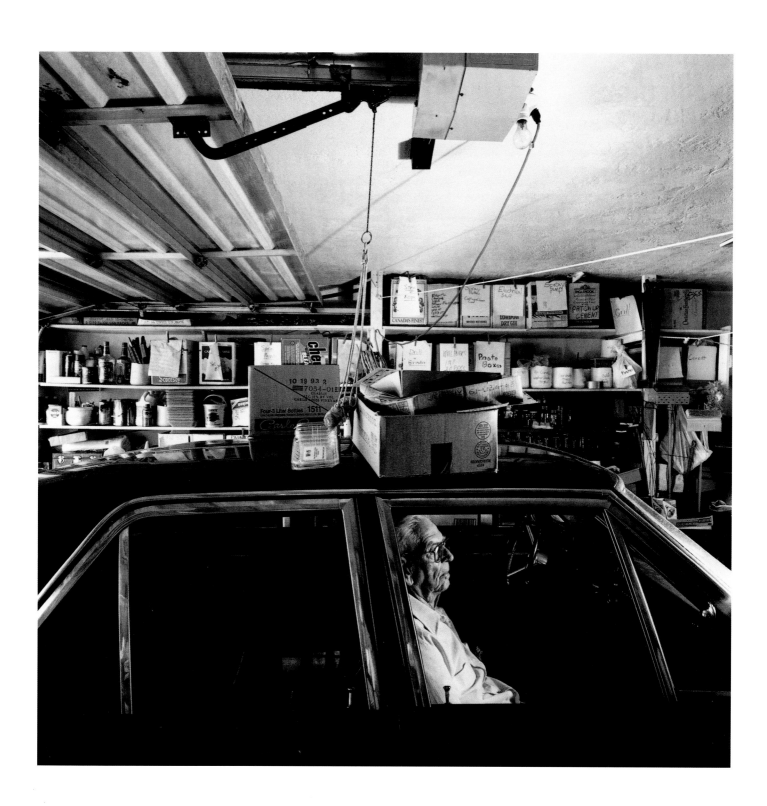

Shrub Car, South Carolina, 2000

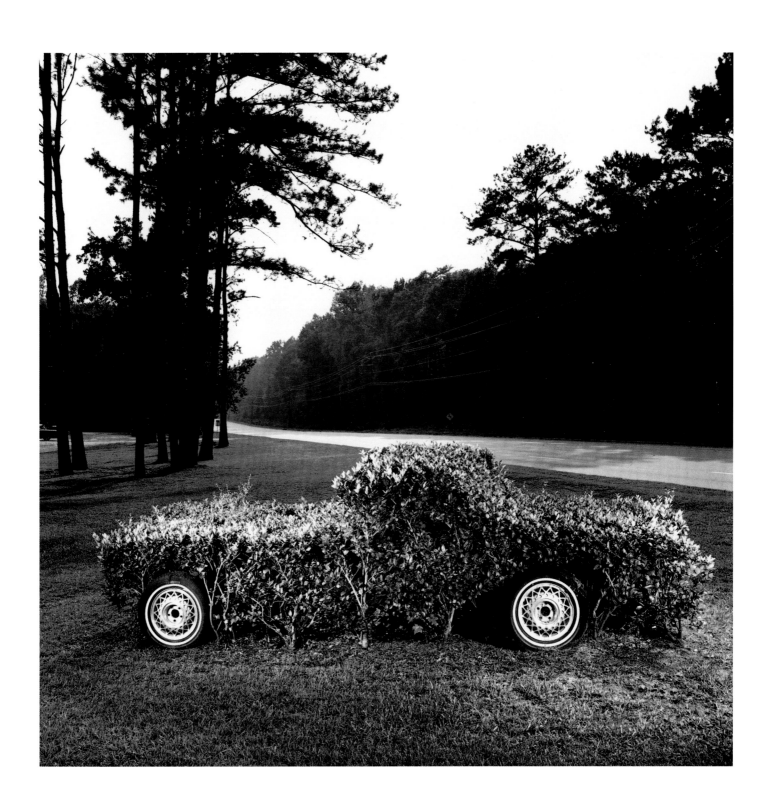

Lady Behind Tree, Gulfport, Florida, 2001

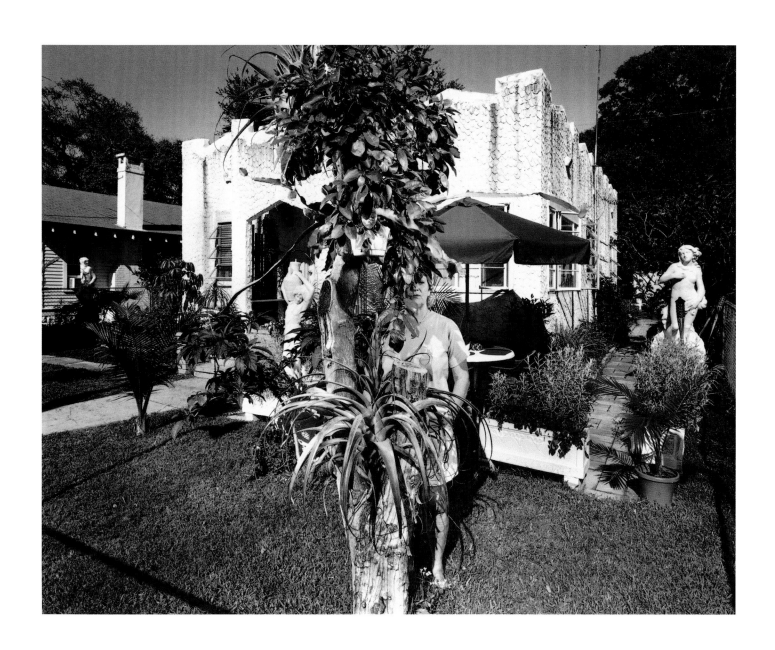

Lunch Break, Delaware, 1998

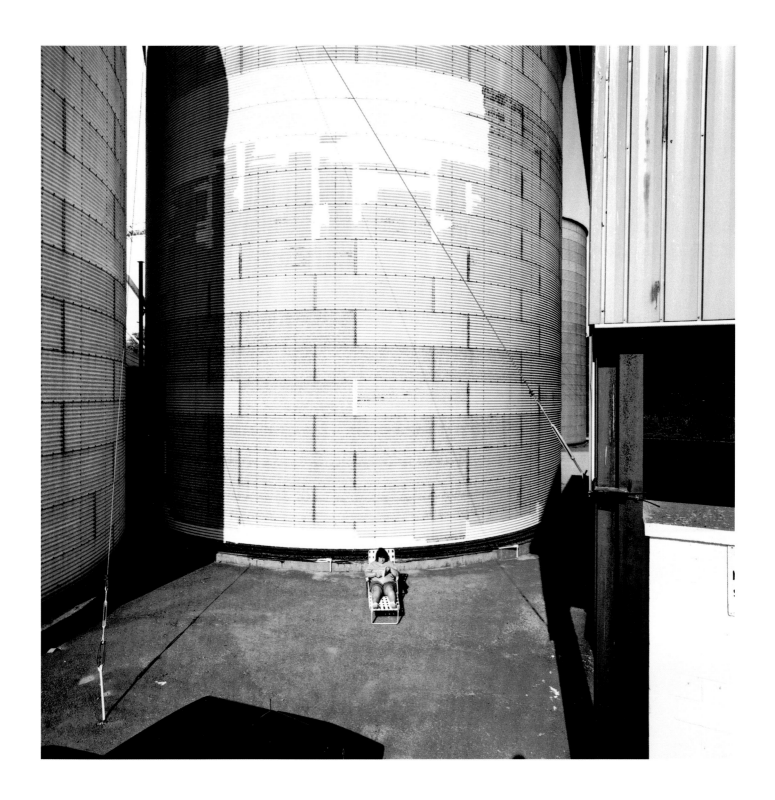

Deer with a View, Little Rock, Arkansas, 1999

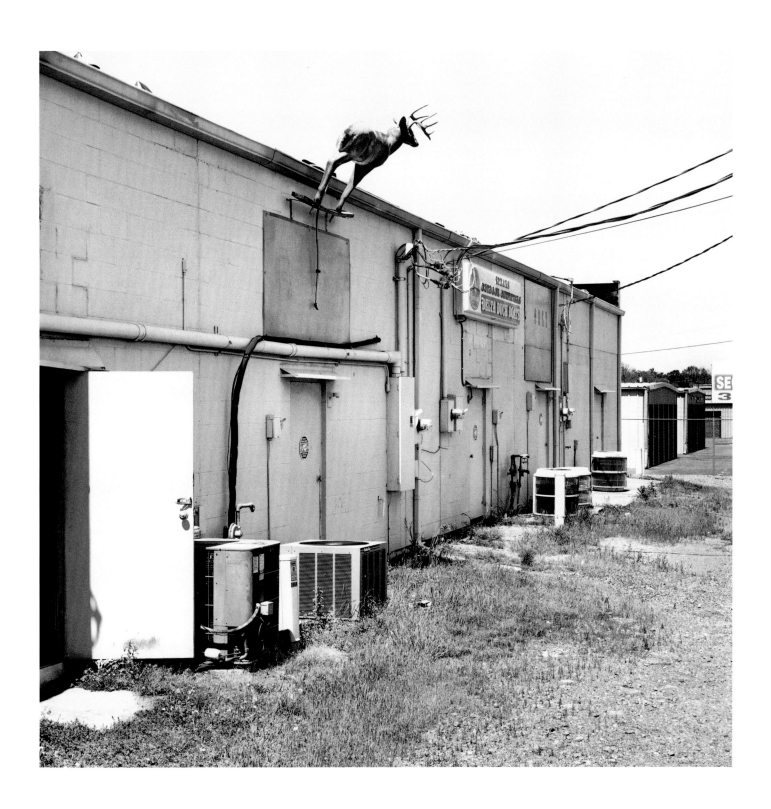

Stressed, Florida, 2005

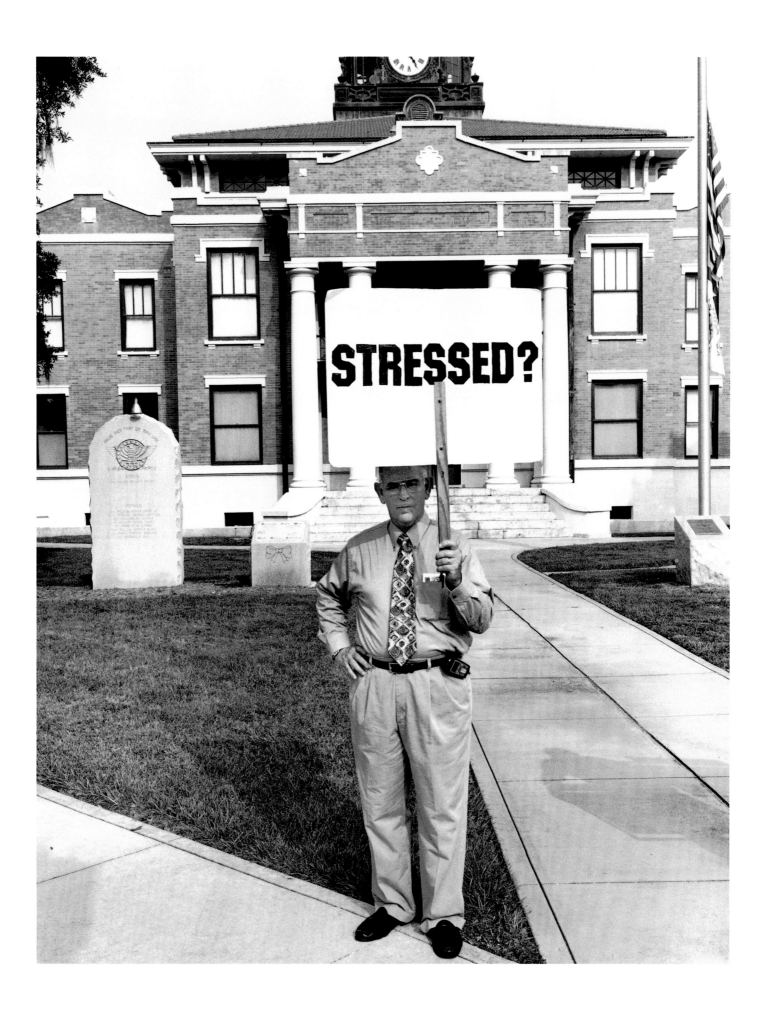

V8 Dinosaur, Weeki Wachee, Florida, 2003

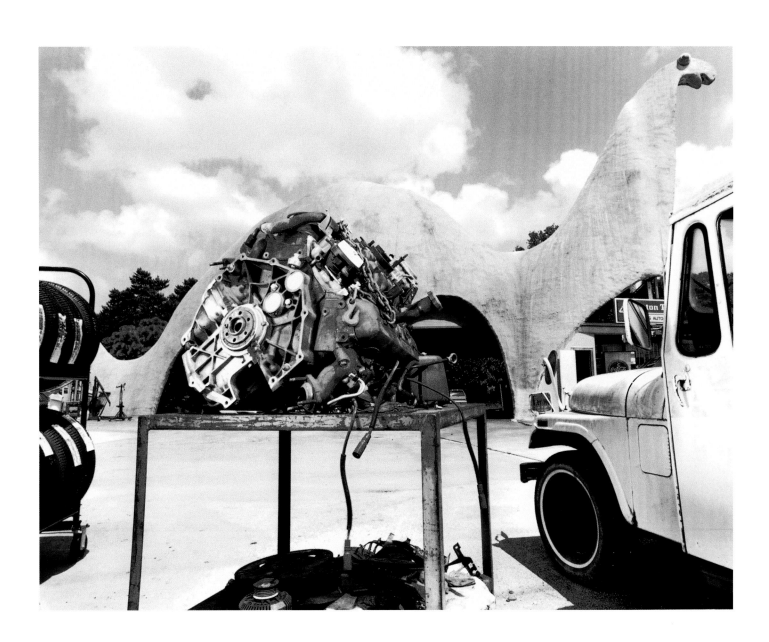

Ice Storm, South Carolina, 2004

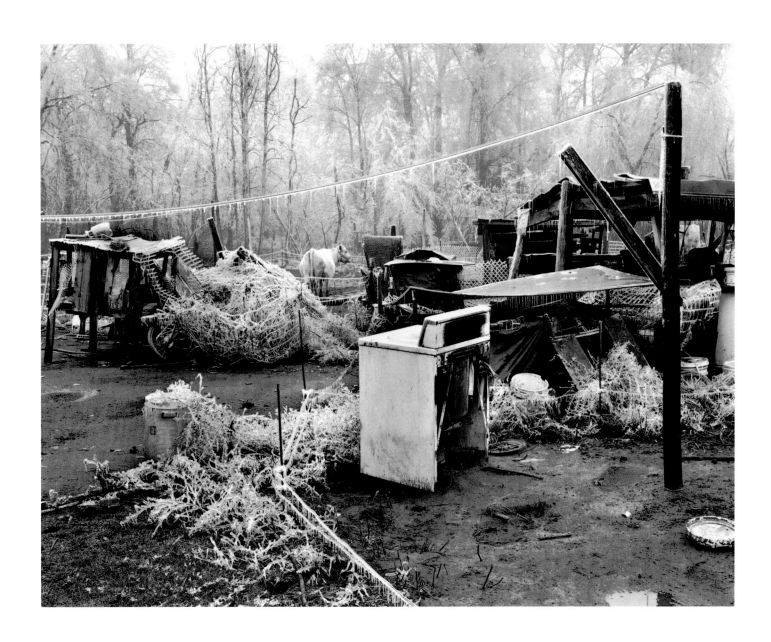

Pole Parking, Georgia, 2001

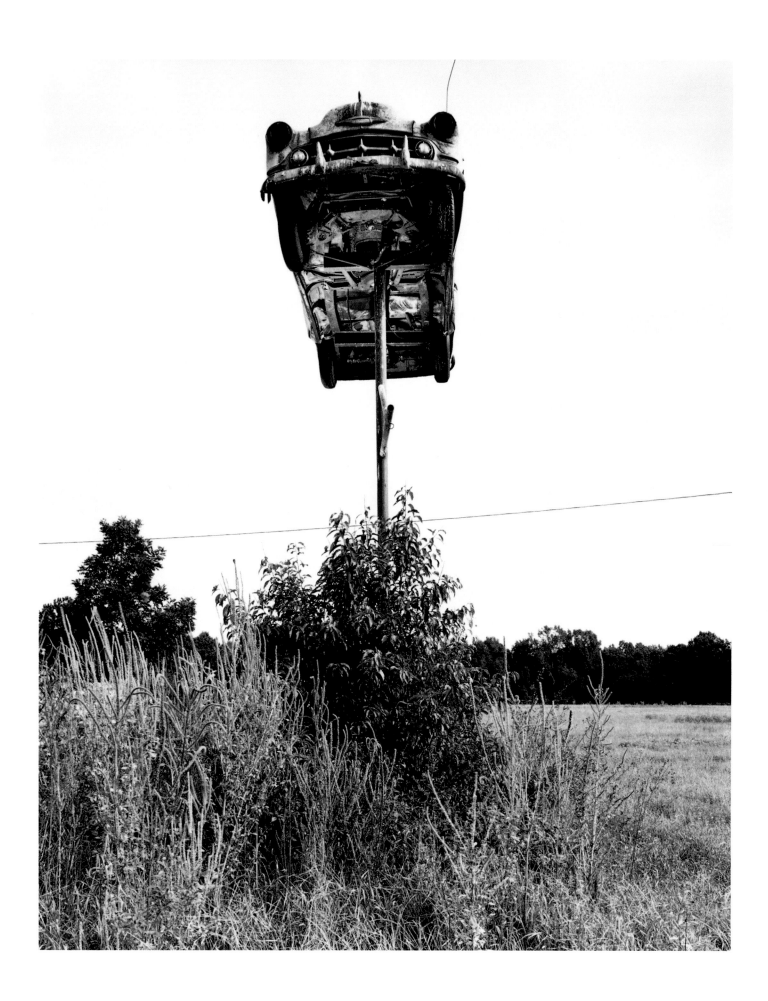

Breakfast for Two, Daytona Beach, Florida, 1998

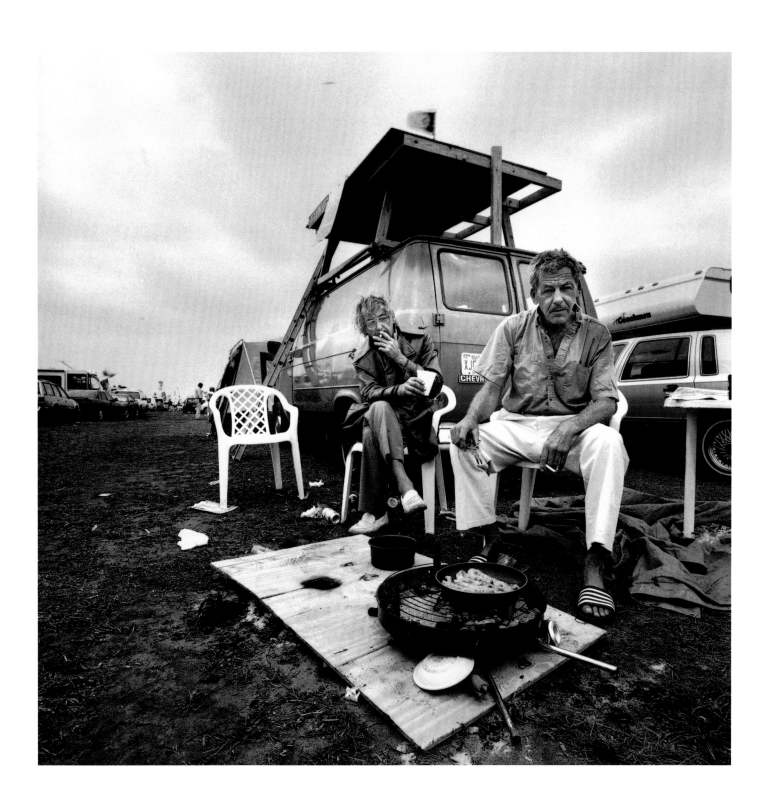

Clothesline with Deer Heads, Texas, 2002

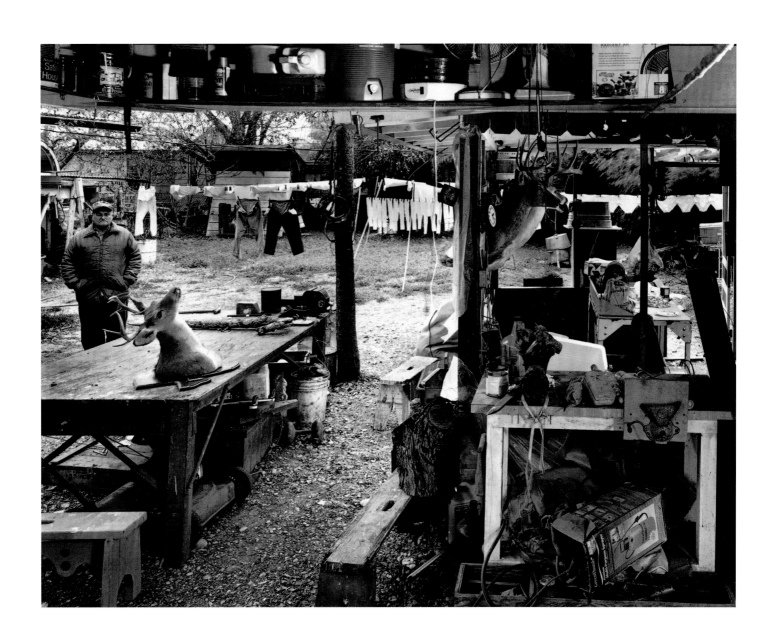

Number One Standpipe, Florida, 1999

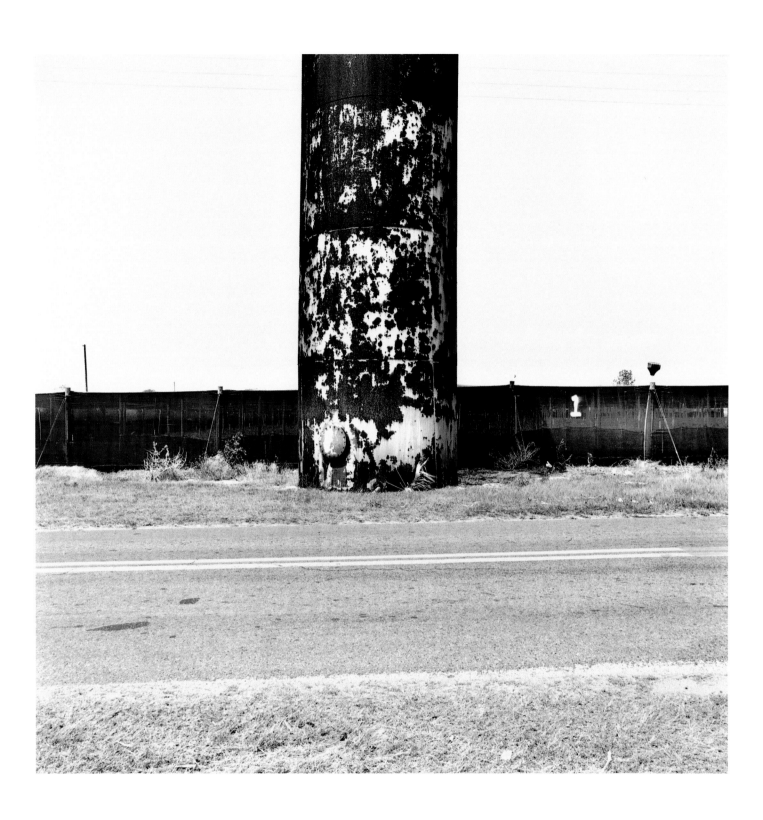

Woman and Pets, Alabama, 1999

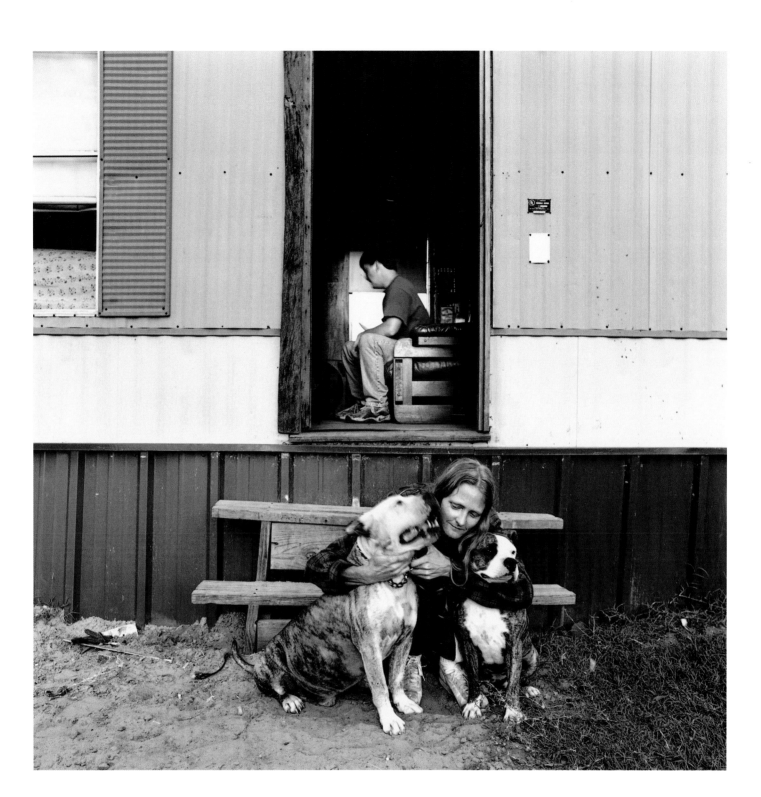

Lady in Personal Pool, Winooski, Vermont, 2002

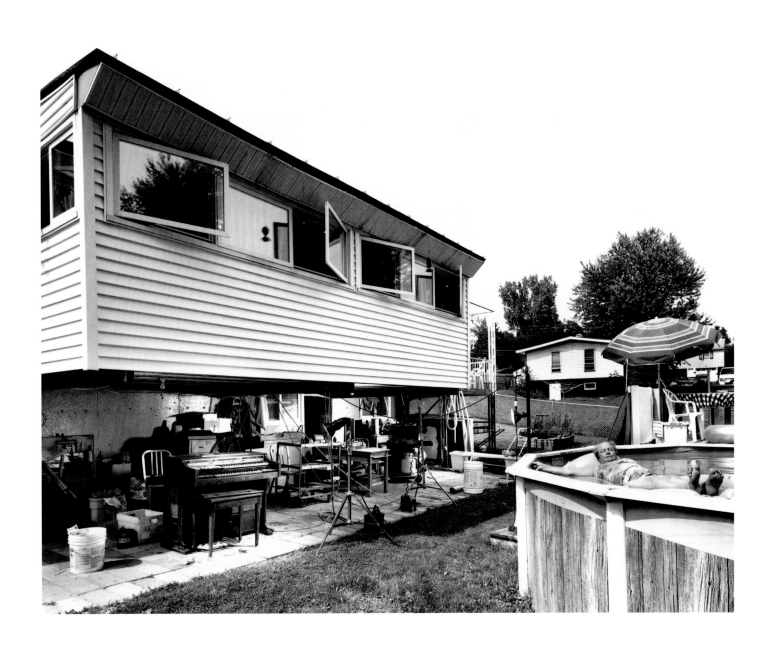

Mud Bog, Florida, 2005

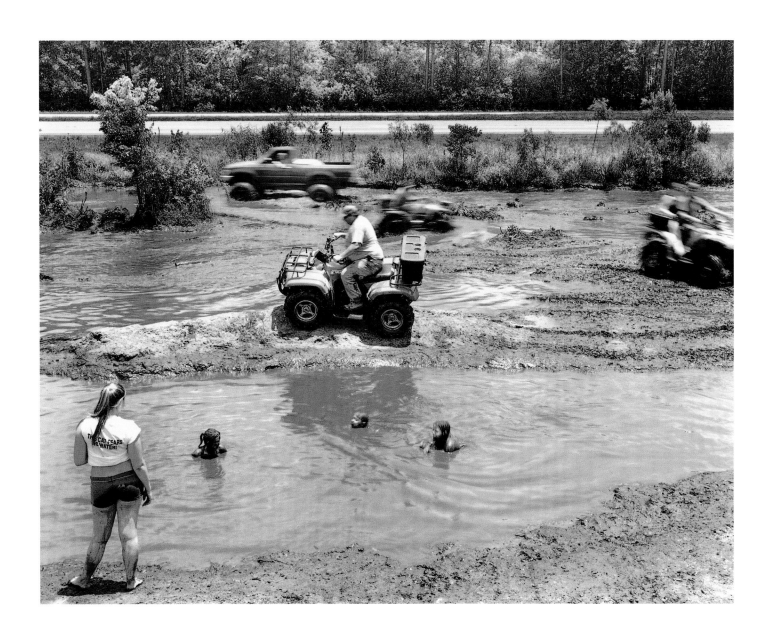

Tree with Identity Crisis, Maine, 2000

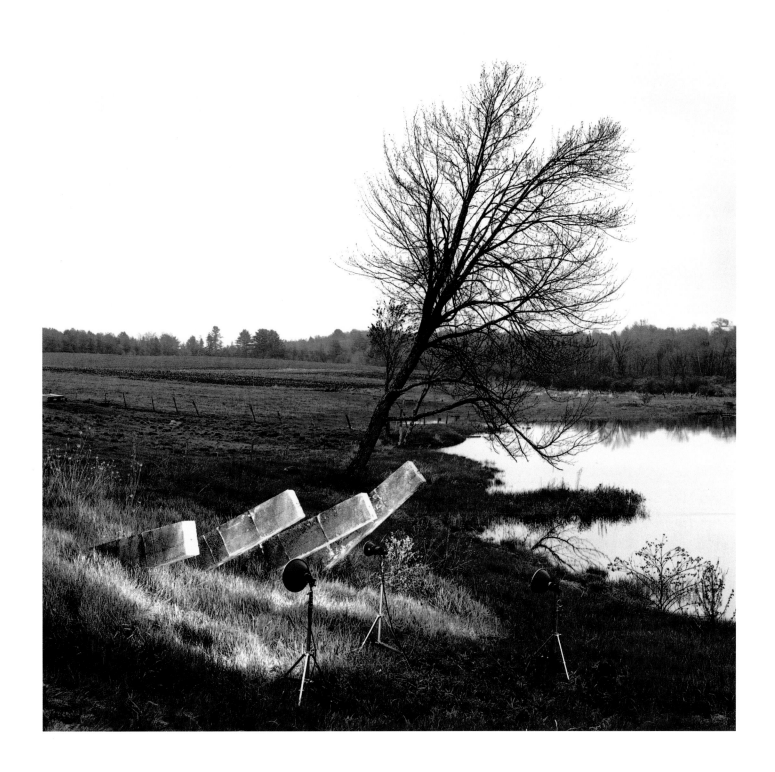

Pepsi Break, Florida, 1998

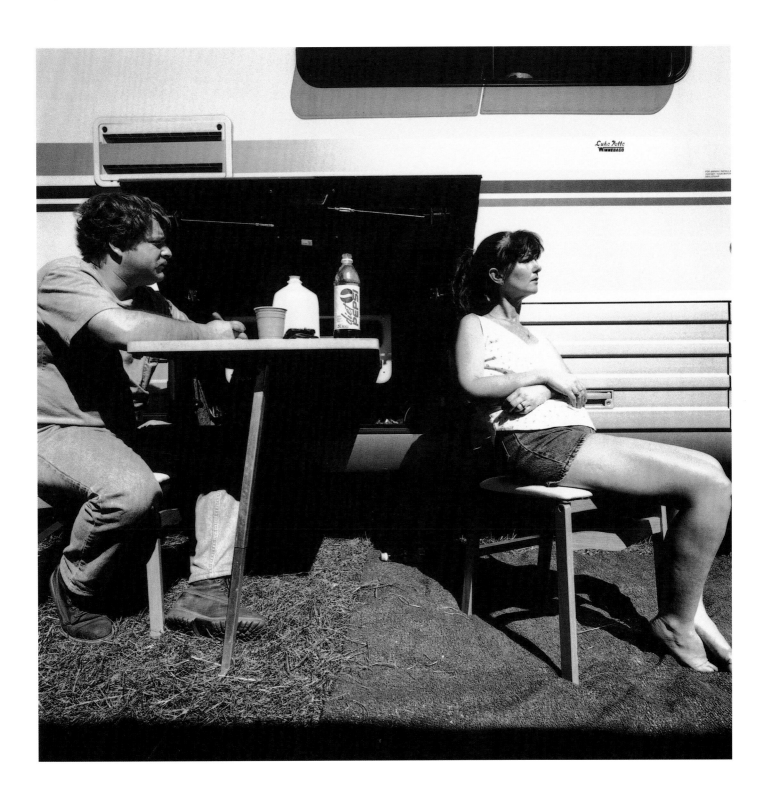

John Herrmann in His Bedroom, Florida, 2005

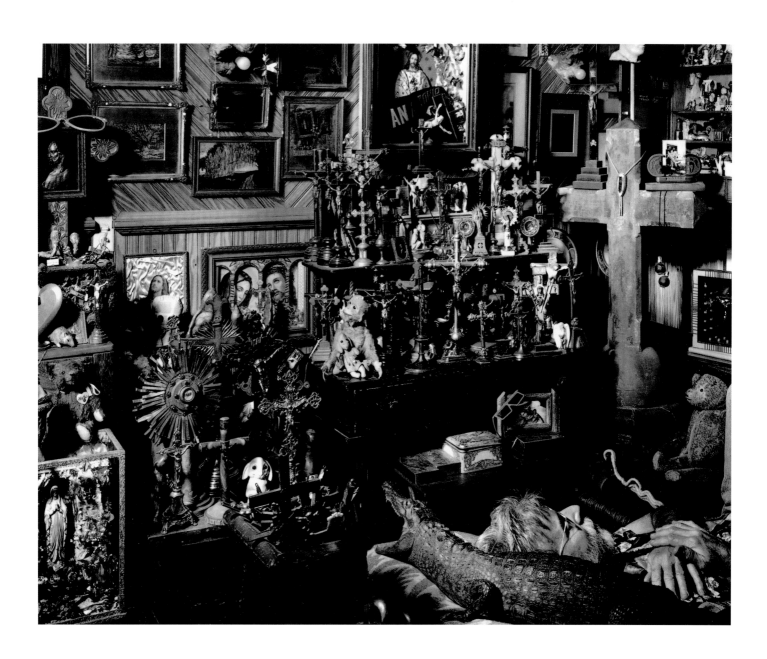

Speedo, Florida, 1999

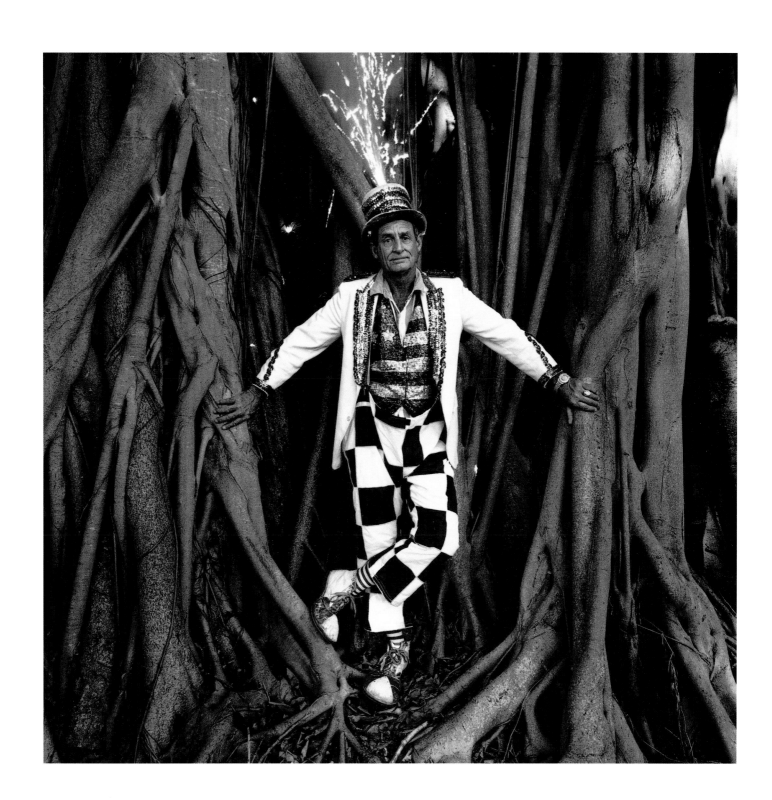

Christmas Spirit, Mississippi, 2002

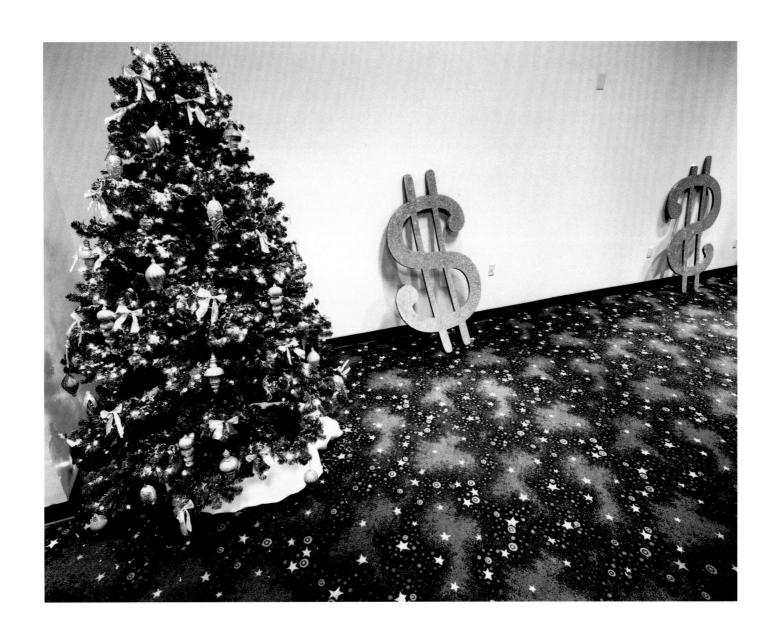

Wild Cat Ranch, Nevada, 2003

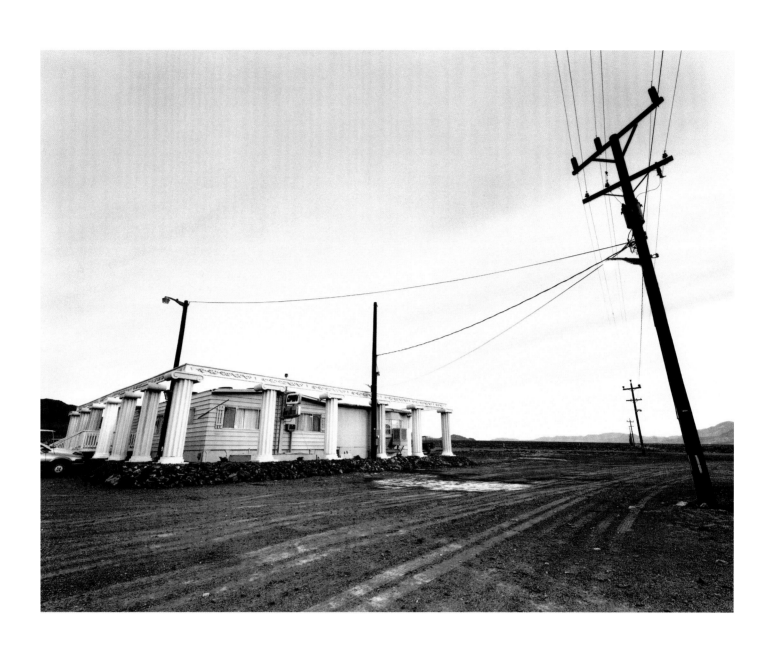

Superwoman, Illinois, 2002

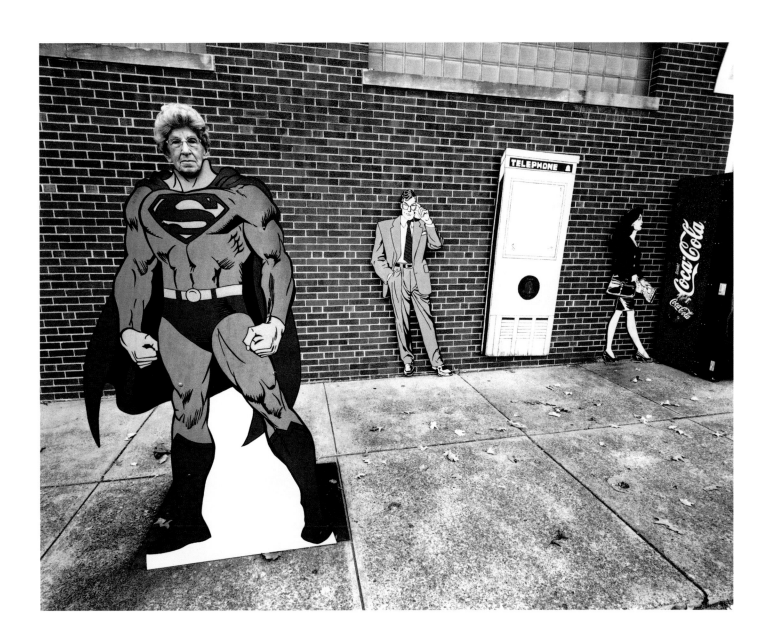

Celebration with Toilet Paper and Pavement, Alabama, 2005

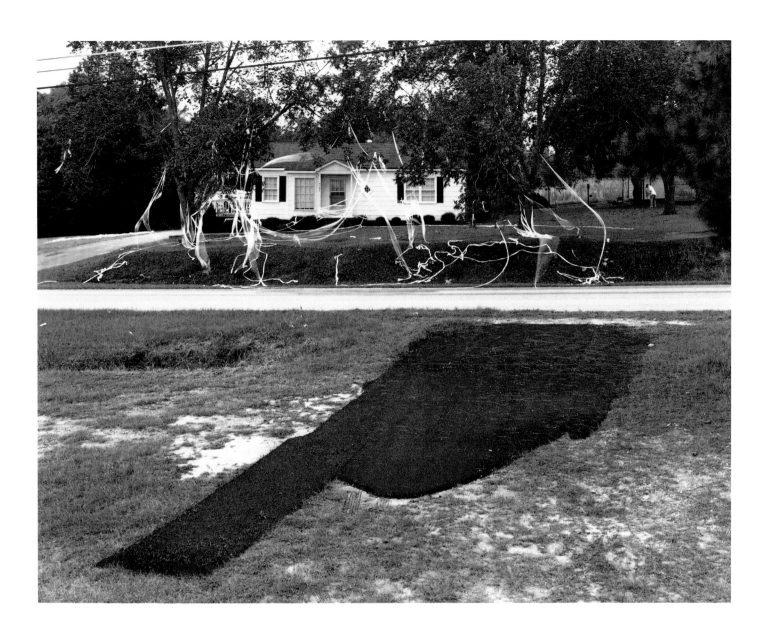

Elvis with Wife, Florida, 1999

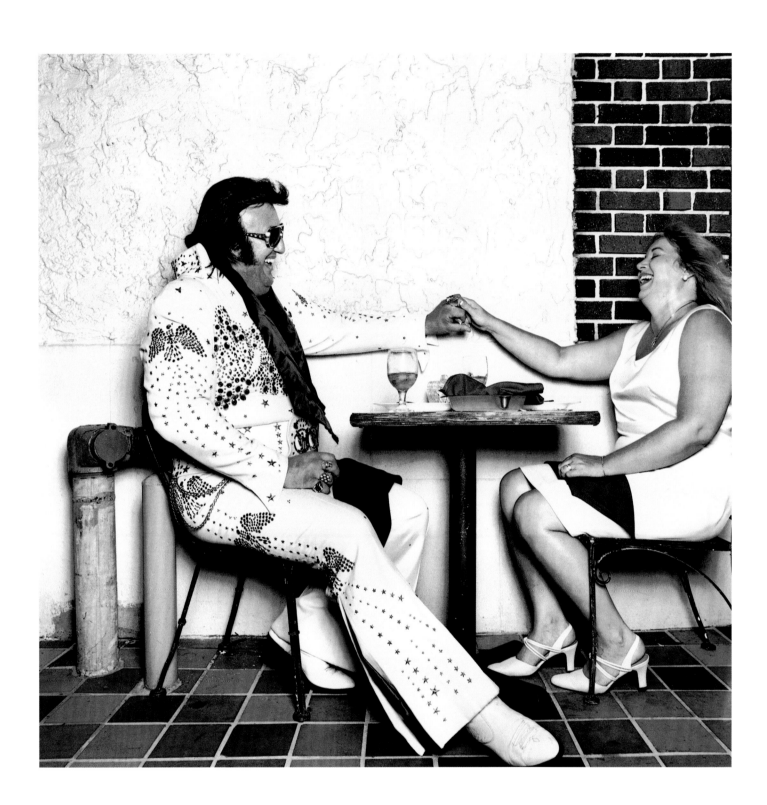

A Family Named Spot, Daytona Beach, Florida, 1997

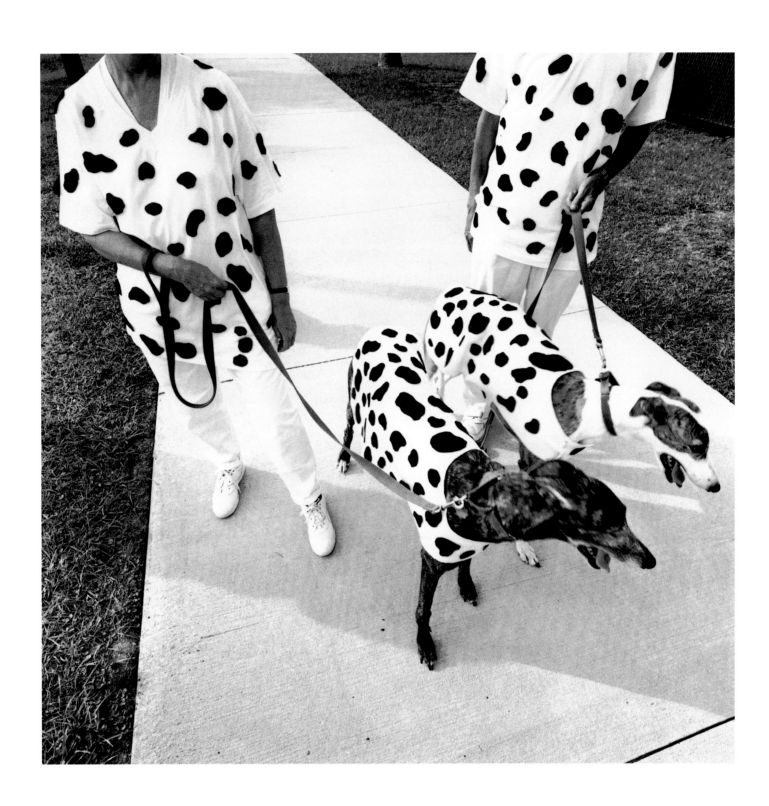

MY HEART IS A SNAKE FARM

by ALLAN GURGANUS

I HAD A SNAKE FARM IN FLORIDA. Well, Buck really owned it, but I believe I'm still Board Chairlady. Almost overnight, he hand-sculpted a one-stop two-hundred-reptile exhibit right across the road from me here. At first it was very clean. It drew lively crowds from the day it opened: December 24, 1959.

Then President Kennedy went and excited our nation about putting a man on the moon. That sicced the Future on any act just roadside and zoological. Tourists soon shot through our state, bound only for Cape Canaveral. Our Seminoles? Our bathing beauties? Passé at eighty m.p.h.

Buck's proved the last stand of pure unregulated carny spirit: back in '59, anybody with a placard, some Tarzan gimmick, and a big mouth could charge admission. And you'd pay. And later, even if feeling somewhat stretched and peppery, you'd still be glad you paid.

I myself had just retired from life as a grammar-school librarian. I was an unmarried woman of a certain age, imaginative as one could be on a fixed income. I'd felt a growing hatred of Ohio's ice, of shoveling the brick walk I knew would break my hip if I stayed another year. I was and am a virgin, my never-braced teeth too healthy. Toledo's secret nickname for me even as a girl: Little Threshing Machine.

My worst vice? Letting others *see* me gauge their foolishness. So claimed my lifelong housemate, Mother. Even so, fellow-librarians did make me a national officer, thanks to my way with a joke, my memory for names, my basic good sense. And because, at our dressy conventions, everyone looked better than I and they all knew I knew.

An old college friend urged Florida on me. "But, Esther? Be careful where you first settle. Danger is, once you're sprung from these fierce Toledo winters, the first place you find in the Sunshine State you will—like some windblown seed—take fast tropic-type root." She was a prophet. I drove past Tallahassee and, eager to make good time, got only as far as a crumbling pink U.S. 301 motel called Los Parnassus Palms. "Somebody's thinking," I said, hitting the brakes of my blue Dodge. Been here ever since. Rented a room by the night, week, then year, and wound up buying the whole place for less than my Toledo town house cost. I still keep the towels fresh in all twelve suites.

A previous owner had named (then plaqued) each luxury efficiency: "The Monterey," "The Bellagio," etc. True, I never knew what such titles meant. But I accepted them as part of History's welcome by-product, Romance. Some suites I lined with library shelves, others served recreation needs. E.g., 206-B, "The Segovia": *Periodicals, Ping-Pong, Reference.*

I didn't care to chat up strangers nor wash the sheets of hairy men. So I switched off my place's wraparound neon. But a motel cliff-hangs its highway the way waterfront property has lake. Salesmen kept honking, believing that dead signage (plus one cute wink) might mean a discount.

Now, to me, Virginity and Refrigeration have both always seemed blue. Ditto one small steady "NO" burning before a too pink and ever-blinking "VACANCY." So, ten days into ownership, royally sick of explaining myself, I flipped on that blue "NO" full time. Redundant, you say? With me age sixty-seven or eight? Well, let's get this part over:

As to sex, I had one chance once with a beautiful boy but I chose not to. Actually, it was the father of a friend but it seemed wrong in their sedan in the countryside, and I thought there would be other takers. There were not. You can wind up with nothing; but, if you claim that and don't apologize and forever tell it straight, it can become, in time, something. It's not for everybody to marry and have kids, or even to be homosexual. Or even to be sexual. But you can still retire and

155

move to the semitropics and wind up on the board of a Serpentarium. You never know—that's the thing. And I say, thank God.

EXCEPT FOR TWO MIDDLING HURRICANES, my first year in Florida proved ever quieter. I'd always said I liked my own company; well, now I had twelve cubic suites' worth. In identical bathroom mirrors, I found one tusky similarity saying, "Esther, you again?" True, the most intellectual Baptist ladies hereabouts invited me to join a Serious Issues book club; yes, I re-linoleumed my whole second story; by then it was almost 1960.

The previous October, Mother'd finally ceased ringing her favorite little bedside bell. I had put it there for emergencies, but soon a moth in the room, any passing car, warranted much brass. By the end, I asked the morticians if they would please place Mother's service bell right in the coffin with her. These large, kind men remembered me lording it benign over their grammar-school library. They now said, "How sentimental. So your mama, in case she wants something, can ring for someone else in the next world?" I lowered my eyes. "Exactly," I said, but thought, *And ring, and ring.* I let gents believe whatever version of me they found easiest to take.

Now I'd retired to wearing flats, finally becoming my own silent hobby, imagine my alarm when the two acres right across my highway here blossomed into Carnival overnight. Someone had leased that swampy inlet and its entire adjoining beachfront. He'd claimed my sole view of the ocean. One morning, two black Cadillacs, sharky with finnage, rolled up, pulling silver-bullet Airstream trailers. A pile driver soon pounded what looked like sawed-off telephone poles right into pallid sand dunes.

The man in charge, I saw from my perch, was a big tanned white-haired fellow, all shoulders and department-store safari gear. He supervised via barks and backslaps, using his beer bottle as a pointer. I always resist such showoff males. (They never notice.) I served under three similar swaggering principals, mere boys. Any Ohio man willing to be called "third-grade teacher" for a few years got promoted above capable senior women. Now I watched this particular bull, six-two, fifty-eight if a day. Dentures probably.

Across the poles, he hand-stretched huge canvas placards pulled tight as fitted sheets. Each showed a different Wild Animal of the creeping, crawling, biting variety. The ocean? Already upstaged. (First a showman hides something, then he describes it so you'll shell out the admission.) Braggart images looked wet with all the drippage colors of tattoos. Crocodiles were shown big as green Chevies. Black snakes glistened in figure-eight oil spills that then lashed up the legs of screaming white girls scarcely dressed. The more pictures this hatchet-faced lion tamer rigged aloft, the slower flowed traffic on old U.S. 301. Beasts scaly, beasts spiny, swarthy, twisted, fanged. "Come one, come all." Not wholly uninteresting.

Meantime, I dragged a cushioned bamboo lounger out of "The Santa Anna." Arms crossed, jaw set, I settled in, daring him to get one centimetre tackier.

The salt-white dunes soon swarmed with antlike workers. Into sand, using driftwood, the head honcho drew a large scallop shell, outhouse-size. He pointed where he wanted it built. Bricklayers scratched their heads then shrugged but, laughing, nodded. Many cinder blocks got unloaded. Within hours, the men had formed three steps, each mitred round as a fish gill in "Fantasia." Atop these stairs arose one little Aztec ruin dropped beside the sea—a ticket booth, glass-fronted, scallop-crowned.

As masons mosaicked, Jungle Jim praised his artistes, fed them grilled sandwiches, tried their trowels while squinting past his cigarette. His big piñata head moved side to side, judging, as he framed all this beauty between his thumbs. He once backed too near traffic.

Three attractive young women, using hand fans, kept their folding chairs aimed wherever he largely stood. By six o'clock,

his cinder-block fortress, shaped like some goldfish bowl's hollow castle, had been painted an odd pistachio-meets-swimming-pool green.

All day, hands on hips, making a jolly silhouette, the man laughed and threw his head back sort of thing. He seemed as entertained as I by how his fantasy could rise in hours from sketch to housing. Come ruddy sunset, these circus folk threw tapering shadows that spanned traffic, just hooking their heads and shoulders into my parking lot. The showman (roughly my age, I now decided, though some men carry it better) mixed two clear pitchers of Martinis. He and his workers toasted their structure and everyone watched the sun sink pinky-gold behind it. Then the boss—with a bullfighter's slash—tossed his whole Martini up the stairs, cocktail glass shattering into sand. His women, stirred, saluted him by knocking back their drinks in single gulps. Thus ended their first day here.

IF SUCH A WHITE-TRASH EYESORE HAD SPRUNG UP across the street from my Toledo mews town house, I would've swarmed City Hall with two hundred other irate owner/career girls. But here, even seeing my oceanfront eclipsing fast, I squinted from my greenhouse (formerly 202-A) while pretending to read Fiction (206-C), doubting that things could grow more Gypsy-ish.

The level of construction across four lanes of traffic soon became almost too complex for even me to track. Then two huge snakes arrived U.P.S. How could I know the bundle contents from this distance without using Mother's surprisingly helpful mother-of-pearl opera glasses? Hints: serpent-package length, two added suitcase handles, triangular orange Caution stickers, airholes thickly screened, and how the delivery boy, wearing shorts, held these out like barbells, far, far from his plump legs.

The carnival's first six days here, I played hard to get. I deprived management of my company. I did not even wave. They seemed to be coping all too well.

Nothing like this had ever so directly threatened my privacy tropique, my sense of self. Of course, the previous year, our retired librarians' newsletter, *Ex Libris*, had announced, "Guess which colorful national officer just retired to and purchased her own 'compleat' Florida motel? (As yet unlisted, she is 823-887-9275.) Yes, our darn Esther!" Librarians fetched up here so thick I thought of it as filing. I stuck the Altoona crowd in 104-A, "La Sangria." The louder Texans I sent on purpose to the leaking 307-B, "The Santa Anna," as an Alamo pun that only I got. Eventually, I hung sheets over my office door and windows. And, slowly, even those big-time lending librarians greediest to borrow a free sunny room got the hint. Circulation dwindled.

Alone I was again. Mother's bell had been muted by six feet of Ohio loam long since frozen solid. My studying the ocean? Worth maybe three full minutes daily. Now what?

The ringmaster across my highway finished digging a whole lake using his yellow rental bulldozer. From floor two and then from my flat roof, I caught chance peeks at his radical new land use behind the screening placards. Finally, one afternoon as I sat reading, all at once, in the bull's-eye center of the lake he'd scooped, up spouted a wild central jet. It went off like Moby-Dick sighing straight aloft. This secret fountain caught me utterly off guard. I felt surprised, then half scared by such a tacky surge, felt something possibly akin to sheer dumb joy. A column of white foam shot forty feet, then fell heavily aside to make a plash, half violent, half joke. My every suite felt cooled some eight to ten degrees.

I rose. I saw that I had been a snob. These dark, pretty circus folk were new here and living so en masse—and God knows I was none of the above.

At last I understood it'd been Mother, that old eighty-five-pound Denver boot, still holding me back—her scoldings about manners and the standards required of a family fine as ours. She'd never let me play with my favorites, twins, "coarse, grocer's

daughters." Having risen, I now slammed shut my third time through Pearl S. Buck's "Good Earth." Why be trapped in the past as some Chinese peasant girl when I had Maturity's sloppy, festive here-and-now?

Darting downstairs to my office-kitchen, I pulled forth a fresh-baked piping coffee cake, carried it bold across the highway (as soon as the steady stream of Key-bound tourists allowed a gap for a running gal my age). That's how I first met Buck and his wives.

"WELL, AREN'T YOU THE PERFECT WELCOME WAGON," he himself spoke, deep. "We noticed you seemed to be in every window. Sure you ain't triplets? Does your coming over mean you forgive a guy's menagerie for complicating your property value? But aren't you scared my prize Burmese python will wind up in your"—he squinted at the unlit neon—"Parnassus Palms dresser drawers?"

"That a threat or a promise, sir?"

Well, this cracked him up. "You're a right good sport."

"Looking like this, do I have a choice?" The ladies laughed, he didn't. I am such a patented virgin I can say things only some ancient cross-eyed nun might risk.

"Everybody has a choice." Buck met me head on. "That's what we mean by 'sport.'"

Soon, over a berry-pink Daiquiri in a teak-lined trailer, I asked Mr. Buck how many snakes he owned—did he hire them from some animal-theatre agent or catch his by hand? The man's voice had gathered accents from pretty much everywhere. These were basted in a unifying baritone the hue of Myers's dark rum.

"Some, lady, I did personally snag in Brazil. The gators seem to find me. Mowgli, she swam up a service-station drainage ditch in Kissimmee. I rescued Stumpy after he fell in some bad motel's pool, no offense. My gators start, like seeds, small, but you feed them into becoming attractions. Funny, but they're loyal in their way. The fancier snakes I have been known to order by phone but will probably *say* I caught bare-handed. I *did*, by dialling Princeton, New Jersey, same outfit that pervides mice to your finer cancer labs. Yep, always have been fascinated by the cold-blooded. As a kid, I tanned muskrat and otter pelts, kept corn snakes as pets, pretty, nonpoisonous. Been on my own since I was nine. Lost Mom to diphtheria, Dad to a travelling lady preacher. So be it. A longish adventure.—But enough 'bout me. What's your setup, Esther? You didn't start in Florida. Naw, you're like me. On the lam from another buncha lives squandered elsewheres, eh?"

I lowered my eyes, unwilling to seem simple as the word "unopened." But then Buck did something unheard of. Awaiting response, he looked right at me. I peeked back up. I stood here and he stood there, with his ladies slouched on all sides, and he did not avert his eyes or flinch, not even men's usual once. "Ouch at first sight," I call it. My teeth are independent; each has its own unique sense of direction. And my hair, despite backcombing, has grown somewhat thin on top. All my life, even when I was six, males have treated me like The Maiden Aunt. A self-fulfilling trend. But this Buck, he stared straight at (not through) me. Seemed only he was strong enough to take it.

BUCK SOON BOUNDED CLEAR ACROSS NORTH- AND SOUTHBOUND LANES, inviting me to his show, for free. He'd asked everybody door-to-door for miles, be they massage parlors or churches. His toylike bulldozer had by now piled real hills around Buck's spitting lake. He'd imported full-grown royal palms. He made the white gravel paths look almost natural, going nowhere, if fast and in four-leaf clovers.

Pastors, bleach-blond masseuses, two education-minded Negro couples, and a bunch of mean little boys gathered, plus

me. "Everybody 'bout ready? Come one, come all, then. Price is right, if today only." Then he performed his entire test spiel. Buck's first jokes did seem stale, even for 1959 ("Welcome to Florida, Land of Palms . . . all open!"). But it was like a starter try for us all. If he tended to ramble, en route Buck charmed, too. He mapped out Amazon rainy seasons, warned of visa requirements, described his sleeping-sickness onsets. He showed early claw damage to one forearm. Facing certain snakes, he recounted their especially nasty captures. As he grew loud, his creatures got stiller and even beadier-eyed, as if out of guilt. He draped any creature not gator-weighty around his neck. Like leis that flexed, they seemed to like it.

When Buck laughed, he gave off a smell like flint, ham, and 3-In-1 motor oil. Active as he was, one of his fingernails was always black-blue, coming and going. He lived in his great-white-hunter gear, jagged khaki collar, epaulets. Pall Malls got buttoned into a customized slot, the Zippo slid snug into its own next door. This man had a brown face like a very good Italian valise left out in a forest during World War Two and just refound. Weathered, but you could still see how fine its starter materials had been.

Oh, he had some pips in there.

Alligators, about forty, and three were the stars—huge, I mean as big as ever I saw in Mother's precious back numbers of the *Geographic*. As with cows, they had whole *sides* to them. They loved their new lake; they showered in its hourly fountain. Huge amounts of lettuce were eaten. (Buck had already payolaed the produce clerks from Piggly Wiggly and Winn-Dixie to bring their castoffs here instead of leaving them lonely in trash vats back of stores. He also fed his reptiles frozen chickens— claimed the birds' iciness made a crunch the beasts considered their own achievement.)

I soon noticed grocery trucks over there at all hours, as much for curiosity as delivery. TV stations covered his Grand Opening. By now, the show was charging full admission and Buck let each visiting child feed one gator apiece. The kid would inch out on a diving board wearing rubber gloves to keep from getting lettuce drool on his little paws. Parents took snapshots. I feared a lethal topple. I briefly wondered about the Reptile Farm's insurance picture; then, suspecting no coverage whatever, thought of something else. Smelling chow, gators hissed like gas leaks. Large white mouths opened, a fleet of Studebaker hoods. Seemed it was always time to feed the gators. Loose luncheon meats, crates of limes, you name it—they ate everything.

BEFORE BUCK AND HIS WIVES APPEARED, my afternoons had been somewhat less eventful: the local library (open 3–5 Tuesday afternoons) featured only past-due best-sellers stinking of Coppertone. Come 1 P.M., I had been mostly monogamous with my favorite soap, "The Secret Storm." Sure, Fridays I might go wild, pop popcorn. But, finally, in the Parnassus Convent vs. Reptile Coliseum battle? No contest. By then Buck had made me a charter member of the Snake Farm Family Board, meaning I got in free.

His one request: "How's about you arrive five minutes prior to showtime wearing a flowered hat and carrying a purse, Esther? Just to keep up our sense of how my place is classy, scientific, er, whatever. Pretending to listen like you do gives my talks real tone, your being the retired educator. Eyeglasses would be good, even your reading specs. Hell, hon, with intellect and class like yours on view, I can charge a dollar more per customer."

Oh, he was sly, that Buck. He wore a cap pistol rammed into his holster, had on thigh-high treated boots, double-thick to keep the rattlers from snagging clear through. He would be wading into their humid glass booth, where thirty rattlesnakes curled clicking like seedpods on a binge.

Nobody hates snakes more than snakes do. That's part of why we fear them. We recognize our own self-loathing, but slung even lower, so it's armless-legless with self-pity. And yet, even during a heat wave, snakes piled one atop the other like trying

to form some sloppy basket. I did not get why. Myself being a single person, myself with typing margins set Maximum Wide, with me needing 13,500 sq. ft. just to feel sufficiently dressed, simply watching such constant summer skin contact made me feel half ill.

Sometimes if I saw a crowd of cars I might wander over. First I limited myself to Mondays and Wednesdays—plus, of course, weekends. (Mother had always rationed my attending other children's birthday parties: "You come home a sticky blue from their cheap store-bought sheet cakes. You forgive their whispering jokes about your . . . features. Listen to you, still wheezing from having run around screaming till you sound asthmatic, Esther.—No, we're alike. Too sensitive for groups. You are one over-stimulated young lady. So let's just sit here a few hours and collect ourselves, shall we, Little Miss?")

Buck's wives swore that if I stayed away too long certain snakes sulked. How could the ladies tell? You mostly recognized different reptiles by their size and how much of that the others had chewed off. I got to know on sight Buck's largest rattlers: Mingo, Kong, and Lothar. Stumpy was the hungriest gator and often got in the way of others' frozen chickens. Stumps never learned. And he paid dearly with his limbs, his tail mass, and, finally, his life. God bless his stubborn appetite.

After hours, hanging out with wives in the Reptile Postcard Shop & Snack Canteen, Buck claimed he had once bought Hemingway a rum drink in Key West and got invited home to "Papa's" hacienda for an all-night poker game. I usually asked him what Hemingway was really like. Buck would shake his head sideways: "Good talker. Sore loser."

During tours, I don't think Buck's grasp of Latin was all it might have been. More than once I heard some pushy customer loiter before a ragged cage, jab his camera toward Exhibit A, and demand, "Hey, what kind of snake is this 'un here?" "That one? That's a big mean red one is what that is. Sooner bite you than look at you. Now, ahead on our left . . ." People would laugh, not knowing if he was joking or mule-headed. But, with this level of poison around, considering his German Luger and hooked stick, no one ever did ask Buck for refunds, repetitions, or corrections.

After one show, I quizzed him: "I guess it's that people love to be scared?"

"No, dear Esther. It's: people love to be scared by something *new.*"

I looked at him, I sipped straight bourbon.

BUCK HAD BEEN MARRIED FOUR TIMES, and three-quarters of his troubles were still with him. "Buck's harem," locals soon called it. Each gal kept her sleek identical trailer parked behind the back-most palms. I heard tell Buck visited a different lady every night. I'd never stayed up late enough to see. Some part of me did wish he would come nap anytime in any of Parnassus's comfy settings. I kept the central fans of all twelve suites going, just in case. He plainly had no sleeping place not already warmed by a previous nesting wife. "Feeding them's cheaper 'n alimony," one local boy claimed Buck said. But that sounds like any of the hundred rumors that made his stint here on our highway so lively during those glory years of latest Ike-Mamie, earliest Jack-Jackie.

Buck's wives seemed another sort of specimen collection. They wore stage makeup, as if competing with each other during those long hot afternoons spent waiting for Buck's last show to end. Of all ages, his gals were either very young now or had been even better-looking pretty recently. Each still appeared sun-baked with strong ceramic traces of her starter glamour.

Working the concession trailer, they were supposed to sell the tourists food and souvenirs; they mostly drank small Cokes and ate the merchandise. They said funny if cutting things about the paying customers. "With those ears, we should stick ole Clem there out in the monkey cage," or "Some of our exhibits eat their young, ma'am, and if you can't quiet those bawling twins of yours we have the livestock that will." "Now, ladies," Buck came in laughing. "Ladies, m' ladies," shaking his head. He

liked them spirited. Of my outfits, he preferred me in the lilac-covered hat and the white patent-leather shoes with matching bag. He wanted his wives to lounge out front in halters, waving at the cars, bringing in considerable business. (Me, I'd drag a kitchen chair into shade off to one side.) Truth is, the girls looked a little better from sixty-five m.p.h. But don't we all?

COME DRINK TIME, the former wives changed into beautifully ironed off-the-shoulder Gypsy blouses. They sported pounds of Navajo silver and turquoise squash-blossom necklaces that would bring a fortune today. They were always painting their fingernails and toenails or working on each other's. You felt their tensions crest only at the sound of the final blanks Buck fired to end his show. When at last he stalked in, there'd be this pinball ricochet of love-starved looking: him gaping at the nut-brown breasts of one while another studied Buck's flat backside, as those other two gals kept glowering at each other's fronts. Nervous, I once blurted, "Cold Coke, anybody?" and got one hot glare so unified.

His exes were intelligent girls who had not enjoyed my educational advantages. They'd once felt too attractive ever to need those. Doing crosswords out loud between shows, they'd squeal at how I helped. "Flanders Field!" I found myself yelling as my mother told me not to at parties. "Cordell Hull!" The girls soon treated me like Einstein's sister, and I admit I humored them; I let them.

Christmas and Easter, I had the whole crew over to Los Parnassus Palms for my turkey, dressing, pies. The wives arrived in drop earrings, evening gowns. Slinky and powdered, they unfolded from matching Caddies. Buck would wear a crumpled tux that looked like Errol Flynn at the end.

Beloved fellow snake farmers seemed most impressed by my owning countless solid-silver napkin rings from Mother. (Funds she might've spent on her only child's teeth braces.) "Good weight," Buck said, testing, as all his holiday ladies nodded, giving him hooded looks. His wives had each been in or near the Show Business. Buck's first, Dixie, once worked as a juggler's assistant in Reno; Peggy, numero dos, claimed to have been a buyer (estate jewelry) for Neiman Marcus; Tanya was runner-up to be a studio player at Metro pictures in the class that included Janet Leigh. Over wine, they revealed more of Hollywood's sad secrets. Hearing the crazy vices of the stars, I cried, "No. Not him, too! What leading man'll be *left* for Esther?"

(Later, some local yahoo tried telling me Buck had never married those three girls, said that they were just part of his roadside attraction, that their separate trailers made nightly cash admissions possible. I don't believe it for an instant and I think some people on this road have very dirty minds. They adored him. That was all.)

NOT LONG INTO KENNEDY'S ADMINISTRATION, the wives sped off to Bradenton to buy new outfits. That's where the carnies all retire, patronizing a glamour shop the girls'd heard about. I saw their Cadillac scratch off around three, and at four I notice Buck, waving a big white hanky to make cars stop, looking sick as he comes staggering across four lanes of traffic towards my Parnassus Palms. I can't say I hadn't pictured this house call before. But not in crisis, not owing to illness. When I opened my screen door, he frowned, head wedged against one shoulder, and his face was all but black. He handed me a razor blade. "Esther? Either Kong or Lothar snagged me a good one in the back. Here, cut an X. Then pour ammonia on it. Go in an inch at least. I can't see to reach it and my focus . . . It's already all over, focus sliding, Esther."

He whipped off his shirt. Face down, he fell across my rattan lounger. I now stood behind him. Two fang marks weren't hard to find because of all the purple swelling. "O.K.," I said. I dashed to get a towel and the ammonia. I splashed cold water in my face. Buck's upper back was seizing something terrible. And yet its shape was very strong, copper-brown, tapered like a swimmer's. I cut far deeper than I wanted, then blotted at least two pints into a large white beach towel. "Now," Buck said,

"I'm going to have to ask you, Esther. And for a friend like you I'd do it in a heartbeat. Feels I . . . feels I'm going into shock here. I'd never ask for any reason shy of Life and Death.—But, honey, would you suck it?"

I might sound funny if I tell you my thin legs nearly buckled. I fought then not to faint. Blame my seeing his dark blood or my viewing his entire back. More than once I had pictured him across the road there being worked on by his full swarm of wives. I'd imagined how Buck might look shirtless, and he looked better, even with blood, which made this more a movie. With Buck in the lounger, I could not bend forward far enough to help. "Here." I lifted him and led him to my davenport. He was only half conscious and the weight of him was wonderful and tested my full sudden Esther strength. I helped him stretch out there, face down. God, how he trusted me!

I settled on the floor beside his ribs. Finally, breathing for two, I rose up on my knees. My teeth are bucked, as you'll have noticed. My own low-cost form of fixing them has always been to make a joke before others get the chance. "Need a human bottle opener?" I once heard a handsome young man quip to pals (and me only seven, trailing embarrassed pretty girlfriends). But now, knowing I might finally be useful to someone, I managed to say nothing. No Esther jokes today, Esther!

I tottered on my knees, then pulled the hair back off my forehead. My eyes wet, I drew closer to his snake holes. They were like twin tears in cloth. At last I pressed my lips down onto those warm slots black with blood, then, slow, I pulled the poison out of Buck. Into myself. You might think I'm exaggerating when I say that I could taste what was poison, what was blood. The poison was bitter with a foamy peroxide kick to it. But blood seemed only salty and, by contrast to the venom, almost sweet.

"Spit it out, Esther, spit it on the towel. Get all that out of you. I cannot have you harmed, not for a sec. You're so fine, dear. Bless your soul for this." I did as he said. I spewed it out then, just as he told me. I was stooped here over him, him flexed out below me, star-shaped, Buck. I fought wanting to cry like some little girl would then. Crying not from horror, not even from gratitude, but more from simply knowing: *This is my life that I am living.*

"ESTHER, PLEASE HIT ME WITH AMMONIA. Takes acid to counteract snake acid. There. Yeeks, burns so good. Now I'm going to need some shut-eye, pet. You sure did it, though. You got it all or most, and I can tell, dear. But let me sleep, oh, twenty minutes tops. Then I'll be fine. No more than that or I'll get dopey. I will need to do something when I come to. Need to have you walk me around. This has happened maybe ten other times, so I know. But when I do feel stronger and can roll over, I am going to thank you, Esther. Living across from us these couple years, you've made our being here just so much livelier. More civil. And now this. You be thinking if there is anything whatever I can do for you, girl."

Then, at once, he passed out or slept. I eased onto my "Alhambra" breezeway. Had myself a cigarette. I'd only ever smoked two before. But somebody had left half a pack in "Segovia" and I did enjoy that one slow Lucky, pulling smoke way in, letting it find its own eventual way out. Laissez-faire. Then I realized: here, the only time a man had ever told me in advance that I could expect something memorable and I was making my big mouth smell like an ashtray. I had to laugh at myself as I dodged into "Bellagio," 109-A, and swigged down half a bottle of Lavoris. By doing this, I saw I'd made most of a decision.

I only waked him because I felt scared that being out too long might give Buck brain damage or such. I stooped beside my davenport again. "Time," I said. Facing downward, he just yawned, then aimed his elbows out, as if nothing much had happened. So . . . male.

My couch had a new hibiscus print on it, maroon. Whatever blood he shed, it would blend in. But I wished that some might stay there, permanent. So sure, he turned over with a sleepy grin and growled up, "Hiya, lifesaver." First Buck kissed me full on

the mouth then more *in* the mouth. It did not prove so repulsive as it always looked when you suspected two movie actors were sneaking doing it.

Then he told me he'd forever been crazy about me after his fashion and right from the start. Said how his liking me so, it had nothing to do with my First Aid just now. Not simple tit for tat. "So to speak," I said, with the valor of an ugly person trying to make light of everything so as to stay hid.

He told me to go pull the blinds shut, and I did. He got himself to sitting, woozy still. Then he patted the cushion right beside him. I, dutiful, feeling frail as if *I* had been snakebitten, settled just where he showed me.

"You won't forever after blame me or be jealous of the others if we do this once, to celebrate my coming back to life with your great help, right?" I shook my head no. He said, "Nothing to panic anybody. No breakage, Esther. Just one thing I want to do. I am too weak for offering up everything right now. I would black out. But this I know I want." And he slid down off the couch and, first, Buck warmed his right hand between my knees. I wore half-stockings and he soon rolled those down with all the care of the earth's best young doctor. Next, he hooked his hands around my drawers' elastic and pulled the pants out from under me, showing me how to lift up so he could do it easy.

He knew I could not have borne to let him see me all undressed. It was just too late for that much. Too late to do everything. But as I kept my hand on his one shoulder not swollen, Buck's white hair, bristly as a pony's, disappeared under my housedress. There was no false start, none of the snaky seeking I had feared. His tongue was there all at once, its own bloodhound locator system, and it could have been a hundred and sixty degrees hot. I had no idea. It, his tongue, soon seemed to be a teacher of infinite patience, then like a sizzling skillet, a little pen flashlight, now featherweight, now flapjack, then just a single birthday candle that—in time, strengthened by doing lap after lap—becomes the forest fire. I had no notion I would ever respond like this, way below where Language ever even gets to start. In brief, certain sounds were made. Snake-farmish sounds, only it was me . . . I. The "I" that soon had her leg crooked around his shoulder, pushing him away, but he leaned into that so it felt like I was playing him in and out of me at exactly my own speed. He was regular as a clock and I was always knowing where he would have been as I allowed myself and just went off again and again and off again, my calves St. Vitus, my feet dancing spasms. The first time was sort of a sea green, the second time more a bronzy blue—there came a red moment but it ended all steamed in hard-baked stone-washed sunflower yellow.

It ended only because I was too proud to let it go on as long as it wanted to. Which would've been as long as both my life and his. Finally, I said, "There, oh my . . ." and started to make one of my jokes, but my dignity stopped me. Funny, I didn't feel ashamed. I felt dignified. I never understood that this was possible. Having another person here, it was less shaming. It was more a way of knowing we are all alike in this. It was beautiful. It was once but it was beautiful.

"BACON AND SCRAMBLED EGGS AND COFFEE CAKE," I chanted, gathering myself to stand. I knew I wouldn't risk the ugly comedy of pulling up my stockings or regaining my step-ins. Instead I would eat a meal with a man who had just taken my knickers off and he would know that, while we ate. I'd placed new oilcloth on my little table here in the former Main Office of Los Parnassus and I felt glad the room looked nice. He stayed right on till seven-thirty-six. I asked if he wanted my help to get him back across the highway. "No," he smiled. "Let me picture you right here as you are, girl. You're a saint from Heaven and a wonderful, wonderful woman. You're so strong. I love that in you, Esther."

"Well, thank you," I said, not doing anything funny, not daring to ruin this. I helped refasten Buck into his blood-soaked safari top. We had eaten as he sat there in the half-light with the white hair tangled on his chest and the swelling already going

down. He was that healthy, it was cause and effect, once I had hoovered most of the bad stuff out. Fact is, I could still taste him or the poison or probably the mix in my mouth. A blend: walnut, allspice, penny metal, black licorice, lamb medium-well. I watched him go. The traffic parted, like for Moses. "Come one, come all," I whispered through my screen door.

IT WAS BUCK'S FOURTH WIFE TOOK HIM TO THE CLEANER'S. She was not in residence. One July 4th, we heard she'd suddenly demanded half of everything and here he was already sharing with his first three. Her suit tipped him into bankruptcy. I hate that kind of selfishness in women. In anybody. He gave so much. Then she had to claim his car and wallet. The sheriff served a summons mid-show. Flashing lights, sirens, horrible for Buck.

What else shut him down? Not the Health Department, though they could have. Grilled-cheese sandwiches were served to customers off a G.E. appliance meant for home use only and not too often cleaned. Buck's vats, where the gators did their shows (if you could call them shows), those might've used a weekly hosing-down with ammonia, Clorox. I had not volunteered to rush over and help. But *you* try and Ajax around thirty moody rattlers. All I knew, just when our neighborhood's social life had grown so routed through the Reptile Farm Canteen, just as I'd got, first, the taste of poison, then a taste of what other people's physical-type lives must be like and, I guess, daily—here came the state to close him down.

There was a huge new sign: "Snake-Gators-Etc. Going Out of Business. Everything Must Move." Buck soon sold the rattlers to researchers who believed their venom might cure cancer. A nature park outside Orlando sent a huge yellow Allied Van Line for the gators. All thirty-nine (Stumps, deceased, excepted) left here with silver duct tape wrapped clear around their heads, stacked like wriggling cordwood in the back of that dark truck. Oh, it was a black day along this overly bright stretch of U.S. 301, I can tell you. I stood there in Florida's latex glare as the van pulled off with every gator blinkered and discounted, lost to us forever.

In honor of the reptiles' exit, I had worn my lilac hat and all my white patent leather and every Bakelite bangle I could find. We held on to each other, Buck, Dixie, Peggy, and Tanya and me. Plus some young gents and the teenaged boys the girls had flirted with, just to keep them buying Cokes. Buck didn't shed a tear. He was the only one. "Well, I've gotten out of tight corners before, girls. But this is the End of the Age of the Snake Farm, probably. Hell, I'm a realist. All their rocket talk and Russian hatred has nixed many a laugh. Eisenhower and Mamie might've been customers here. But those European-type Kennedys? No roadside attractions for people that French-speaking, clean and stuck-up. Type that changes clothes three times a day without noticing. Thing is, it's nothing personal, way I see it. The Future is here and it gets hosed off way too often. And don't you gals suspect it's all based on damned Bad Science? I think nobody gives good value now, much less a decent doggone show. And where the fuck is the energy and fun in any of it? Excuse me, ladies."

"No sweat," I said.

Next morning, hired guys rolled up all Buck's signs. Those now proved no more substantial than window shades, and yet, for three good years, they'd got to feeling pretty monumental. During windstorms, their canvas snapped like the sails of the Mayflower. That sound and the surf's slamming made this seem the New World after all.

Suddenly, signs gone, the Atlantic's raw horizon showed again. But now it looked like a paper-cut cliff, Niagara. Buck's home-dug lake, gatorless, appeared about as exotic as some miniature-golf-course water trap. Gravel paths bound nowhere now circled back in case they missed it, circled back.

After our group goodbye to the gators, my friends left overnight in the middle of the dark. I later saw that as a kindness, really. The very next noon, a Haitian crew—carrying radios blaring French tunes—showed up like the Keystone Kops. They dug

up all Buck's store-bought palm trees. Root balls were still wrapped in burlap from their last sale. Seeing those trees go off lonely and akimbo on one flatbed truck was like witnessing a slave auction of my friends. Unseen, I waved. From the second-story breezeway, I was physically sick. Well, guess who felt bleak to the point of suicide or moving back to Toledo mid-February?

Weeks after, you would see a Piggly Wiggly truck pull up, not having heard or believed, and with enough slimy salad in back to feed all terrariums on earth.

I NEVER DOUBTED BUCK'S TALE about beating Hemingway at poker and what a whiner Papa was over losing sixty bucks. I believed my friend about his being overnight with Ava Gardner. Buck would say no more than that, except, below his dancing eyes, he kissed all his right hand's fingertips. He admitted just "Ava? Ava was a gentleman." And since Buck had once told me I was also somewhat one, that helped.

Buck had been exactly Ava's type: the best gristle-sample of manhood ever to spring up on the wrong side of the snaky tracks. And a man still male enough at sixty-five or nine to keep three exes fighting for some stray lettuce head of his tossed attention. He never bragged, except maybe to tourists he'd never have to see again. You might think Buck had too little to boast of; but there was, in the high times at the Canteen, in our sole evening of sucking the poison out of one another, a kind of grandeur I can only hint at. After his wives, too loyal and numerous, having heard his pistol, powdered their noses and freshened their Liz-Cleopatra eyeliner, all of us knowing our last show was about to end, and after the day's forlorn clump of exiting tourists spent a few last wadded dollars on postcards and plastic shark-tooth key chains, Buck would come chesting in, he would give us all a cobra smile with real white teeth and, including me, including me, say, "*Qué pasa*, girls?" He had it. That is all I can say. Buck definitely had it.

ONCE THE FARM CLOSED, if you dared walk over there, considering the sad and sandy blankness and those holes where rental palms had stood, you realized most of the cages had been nothing more than double-thick chicken wire. Made you wonder why the snakes had stayed. Maybe for the reason his ex-wives (and I) did. Because this really had been a working farm. Because everybody did his chores, even the snakes who struck against glass, aiming for the sunburned leg of some passing fat tourist boy, just to make him scream and force his mother, once she found no fang marks, to laugh. "It didn't mean it, Willie. That's just nature being nature, is all. That's what snake farms teach us, son."

Buck's show evaporated overnight, and highway traffic sure moved faster all through here. Especially after a new Japanese-owned driving range removed the Farm's every Day-Glo yellow-and-pink lead-up sign. These had once started promising him twenty miles due north, due south:

YOU ARE NOT BUT SIXTEEN MILES FROM
BUCK'S REPTILE FARM: SNAKES AND LIZARDS
SEEN BY THE CROWD HEADS OF EUROPE!
"EDUKATIONAL" FOR THE KIDDIES, TOO.
LARGEST GATORS IN CAPTIVITY:
MONEYBACK GUARANTEE OR A CLOSER LOOK!

That was my Buck all over.

Even now, one snaggled fact still stands there. Greenish and flaking, it is chipped like a Greek temple salt-preserved in Sicily: yes, his ticket booth's rounded cinder-block steps arranged in a shape as close to scallop shell as blocks that size could possibly become. And up on top there's the little cement platform, five feet above the sand, where people stood to buy admission for their families. Two hurricanes chipped the booth away in two huge molar chunks. But those steps yet survive.

I told myself not to expect to hear from any of the wives or him once they'd slid out of sight. That proved righter than I'd hoped. Still, wherever they washed up next, you wished them well.

(After all, when these showfolk found me here, in '59, my lady library officer's drink of choice—learned at conventions—had been a sticky cherry cordial. And by the time my snake charmers left in the middle of the night in '63, I'd worked my way straight up to straight Jack Daniel's. Who says there is no human progress?)

Those greened steps now stand framed against only browning palmetto scrub. But here's the funny part. Funny in some small, sidelined way. On a cool afternoon, if you park down a ways then tiptoe back, if you take a peek at the little stage that platform makes beside its bog, you'll often catch three to seven dozing there. Real snakes sound asleep, wild ones. They must love the heat a day of sun leaves banked in those old blocks. Maybe snakes enjoy being dry and up out of their usual mud. But, black snakes and cottonmouths, water moccasins and, once, a red-and-yellow coral snake some boy claimed he saw, they all seem to be waiting. Like auditioning, or hoping for a comeback. They seem to still want in, as paying customers, to see other like-minded creatures, but ones grown huge and therefore notable, forty times their weight. It's as if local reptiles can yet remember Buck's whole vivid show. It's like they long, as I once did, to simply hear how he'd describe them!

SOON AS THE GOVERNMENT CLOSED BUCK DOWN, things grew silent fast around Los Parnassus Palms. I could not have simply left here overnight when my friends drove off. I owned property. Besides, they never asked.

Still, I knew that, if he ever thought of me, Buck would want his good-sport Esther to be getting on with this, her latest life among the others she'd spent elsewheres on the lam. My heart had lately grown so . . . unsystematic.

When I first bought Parnassus, I'd turned off all its signage. Then bargain-hunting oversexed salesmen kept making me explain myself. Finally, years back, I lit just those two low-watt neon letters. My "NO" warned cars away. Through monsoons and dry spells, one blue skull and crossbones—my spinster coat of arms—blazed day and night against stucco.

Five months after the Reptile Canteen closed, I spent an evening fearing the latest hurricane with a name like one of Buck's ex-wives'. As I lounged around the Main Office—alone, naturally—I noticed, there beside the table where we'd eaten our aftermath bacon and eggs and his favorite coffee cake, two light switches. Decades back, these'd been marked in some stranger's tidy pencil script "N." And, below that, "V." I now reached over and, inhaling, with the flair of some magician's assistant, flipped off the "N." Then, taking in two lungfuls of sea air, instead I just hit "V." For victory? Dream on.

I LET IT BURN THERE, out in plain and common view. I cannot say it didn't partly shame me. Pink and raw and overly visible, so all by itself (in its upright fifth-grade cursive). I retreated to our crucial maroon davenport. I settled here, now facing our highways's every southbound headlight.

I crossed my arms and felt surprised to find myself this ready: I would wait again. For what? Something. Anything, though not quite anyone. Heck, I'd already had the best. I might need to make a few concessions next time; I knew that.

Buck used to flatter me: "Cozy how my big Show attraction stands right up across the road from your nice Shelter attraction, Esther." "That's easy for *you* to say." I rolled my eyes to make him laugh. He never failed, and in a baritone mahogany.

Now, almost half a year after losing sight of him, I felt represented by that blinking sign out there. He had taught me it pays to advertise. Come one, come all. It's a human right, to name at least what you'd *like* to offer. True, I might not be any motorist's idea of a final destination; but maybe I could pass as just another attraction along a roadside littered with such.—Because, you know what? You never know. And that's a great thing: how they keep us guessing. That comes in second, right after Hope.

Stranger things have happened than life's stopping twice at one convenient off-highway location. Plenty of free parking, God knows. And now, as each headlight played across the slackened front of this, of me—partly ruined yet still far from stupid—I felt I'd outgrown "NO" at last.

Once upon a time in America, a man from nowhere with nothing but shoulders and great teeth, a guy backboned with one idea while enjoying sufficient sharpie patter—he could put up steps to anything that he might make you see as Wonderful. And without bimonthly federal inspections, without any legal charter past a friend or two he called "our Board," that man could shake you down for exactly the number of buckaroos you'd actually part with. And he would send you off glad, with more of your own personal story than you'd had before he took your cash. And all this without exceptional Latin.

Now, through my office plate-glass, I could see the former site of his Attraction. It was lit up tonight, salt-white sand, edges of white breakers endlessly uncoiling. All viewed better thanks to the sudden commercial glare from here, me.

Burning pink, held up against everything, that one word, a full proud three feet high. Too raw a term. Too rude a come-on for a woman alone of my age and homeliness. Wasn't it too hardened an admission, even for Florida, right along U.S. 301, even at 2:18 A.M.?

And yet, leaning back, breathing for one again, my arms folded over a slack chest, I liked going braless beneath a favorite housecoat worn with only "our" bloomers. I would be smoking now, if I smoked.—Who is this woman hidden back of her neon? Why, it's Esther the Impenitent. Still on the lookout, feeling almost dignified:

VACANCY

Now I knew what it meant.

BURK UZZLE

1938	Born, Raleigh, North Carolina
1955–1956	Staff Photographer, *News and Observer*, Raleigh, North Carolina
1957–1962	Contract photographer in Atlanta, Houston, and Chicago for Black Star Agency, New York
1962–1968	Contract photographer for *Life* magazine, Chicago and New York
1967–1983	Member, Magnum Photos, New York and Paris
1979–1980	President, Magnum Photos, New York and Paris
1984–1997	Independent photographer based in New York, New York
1997–present	Independent photographer based in St. Petersburg, Florida

SELECTED SOLO EXHIBITIONS

2005	"A Family Named Spot," Southeast Museum of Photography, Daytona Beach, Florida
2004	"Burk Uzzle," Laurence Miller Gallery, New York
2001	"America in the Seventies," Bodo Nieman Gallery, Berlin, Germany
1998	"Bike Week," Leica Gallery, New York
	"Bike Week," Gallery Contempo, St. Augustine, Florida
1996	"Correspondence Between Islands," Danforth Gallery, Portland, Maine
1994	"Burk Uzzle: Three Decades of Photography," Inaugural Exhibition, Leica Gallery, New York
	"Burk Uzzle: Recent Work," The Photography Gallery at Drew University, Madison, New Jersey
1992	"A Progress Report On Civilization," The Chrysler Museum, Norfolk, Virginia
1985	"Burk Uzzle," The Ffotogallery, Cardiff, Wales
	"Burk Uzzle," Open Eye Gallery, Liverpool, England
	"Burk Uzzle," 253 Gallery, Norfolk, Virginia
1984	"All American," Philadelphia Museum of Art, Philadelphia, Pennsylvania
1980	"News from Cambodia," International Center of Photography, New York
1979	"Burk Uzzle," Galerie Agathe Gaillard, Paris, France
	"Burk Uzzle," Galerie Fiolet, Amsterdam, Netherlands
	"Burk Uzzle," Witkin Gallery, New York
1977	"Burk Uzzle," Aperion Workshop, New York
	"Burk Uzzle," Columbia College, Chicago, Illinois
1974	"Burk Uzzle," Dayton Art Institute, Dayton, Ohio
	"Burk Uzzle," 831 Gallery, Birmingham, Michigan
1973	"Burk Uzzle," Witkin Gallery, New York
1971	"Burk Uzzle," Art Institute of Chicago, Chicago, Illinois
1970	"Typically American," International Center of Photography, New York

SELECTED GROUP EXHIBITIONS

2004	"The Faceless Figure," Philadelphia Museum of Art, Philadelphia, Pennsylvania
2003	"Leslie Fry, Sculptor–Burk Uzzle, Photographer," Mira Mar Gallery, Sarasota, Florida
2002	"Where We Live," Selby Gallery, The Ringling School of Art and Design, Sarasota, Florida
2001	"Fourteen Photographers," J. Johnson Gallery, Jacksonville, Florida
1979	"Contemporary Photographers," Santa Barbara Museum of Art, Santa Barbara, California
1978	"Contemporary Photographers," Stedelijk Museum, Amsterdam, Netherlands
1977	"Burk Uzzle–Mary Ellen Mark," Massachusetts Institute of Technology, Cambridge, Massachusetts
	"Through Other Eyes," Arts Council of Great Britain, London, England
1976	"Festival d'Automne à Paris," Musée Galliera, Paris, France
1975	"Impact of Design," Nikon House, New York
1974	"100 Years of American Photography," La Maison de Port Deauville, Paris, France
1971	"Contemporary Photographers," Fogg Art Museum, Harvard University, Cambridge, Massachusetts
1969	"Spectrum One," Inaugural Exhibition, Witkin Gallery, New York
	"Recent Acquisitions," Museum of Modern Art, New York
1968	"Photography 68," George Eastman House, Rochester, New York
	"Recent Acquisitions," Museum of Modern Art, New York

BOOKS

Progress Report on Civilization, The Chrysler Museum, 1992
All American, St. David's Books/Aperture, 1985
Landscapes, Magnum, 1973

SELECTED ANTHOLOGIES

Contemporary Photographers, St. Martin's Press, 1982
World Photography, Popular Photography Books, 1981
Album Photographique 1, Centre Georges Pompidou, 1979
America in Crisis, Ridge Press/Magnum, 1969

SELECTED ARTICLES

American Photography Three, 1987

British Journal of Photography, 1985

American Photographer, March, 1985

New York Times Book Review, July 7, 1985

Photo District News, June, 1985

The Philadelphia Inquirer, November 11 and 27, 1984

American Photographer, March, 1980

Photography Annual, New York, 1979

Photo, Paris, October, 1978

Zoom, Paris, December, 1978

Camera Mainichi, Tokyo, 1978

Du, Switzerland, September, 1977

Aperture, No. 77, 1976

Creative Camera, London, 1976

Photo, Paris, October, 1976

Zoom, Paris, April, 1976

Camera, Switzerland, 1973

Modern Photography, New York, 1972

Camera, Switzerland, 1970

Creative Camera, London, 1970

COLLECTIONS

Bibliothèque Nationale, Paris, France

Art Institute of Chicago, Chicago, Illinois

The Chrysler Museum, Norfolk, Virginia

George Eastman House, Rochester, New York

Fogg Art Museum, Harvard University, Cambridge, Massachusetts

International Center of Photography, New York

Library of Congress, Washington, D.C.

Metropolitan Museum of Art, New York

Museum of Modern Art, New York

Philadelphia Museum of Art, Philadelphia, Pennsylvania

Santa Barbara Museum of Art, Santa Barbara, California

Smithsonian Institution, Washington, D.C.

Stedelijk Museum, Amsterdam, Netherlands

ACKNOWLEDGMENTS.

The sense of grace I have always found in the small towns and back roads of
America, and which so defines this country that I love, is what has built this book.
Place by place, person by person, I have been formed by this country.
In my photographs, I hope to show my respect, and to reflect that grace.

In particular, I would like to thank the most gracious of people, my friends.
They have all had an invaluable place in my life and work.

Jeremy Adamson
AC Berkheiser
Kim Blanchette
Lee Dunkel
Leslie Fry
Charlie Gauthier
Phillip Jones Griffiths
Elaine Gustafson
Allan Gurganus
Jeff Hirsch
Peggy Huff
Stella Johnson
Sandra Kurtin
Constantine Manos
Douglas Mellor
Kevin Miller
Laurence Miller
Frank North
Bennett Robinson
Charlie Rose
Ross Watson
Garrett White
Joe Young
William Zewadski

Most of all, for everything they are and mean to me,
I thank my children, Andy, Caitlin, and Tad.

Five Ties Publishing, New York
www.fiveties.com

Produced and edited by Garrett White
Editorial assistance: Amanda Thorpe
Book design by AC Berkheiser

First edition 2006

Photographs © Burk Uzzle 2006

"My Heart is a Snake Farm" was originally published in the The New Yorker, November 22, 2004. Used by permission.
© Allan Gurganus 2006

Printed by Blanchette Press, 8000 River Road, Richmond, BC, Canada V6X 1X7
www.blanchettepress.com

Printed in Canada

ISBN 0-9777193-0-8